G000123618

MATLOCK & MATLOCK BATH

THROUGH TIME

Alan Roberts

AMBERLEY PUBLISHING

First published 2012

Amberley Publishing
The Hill, Stroud
Gloucestershire, GL5 4EP

www.amberley-books.com

Copyright © Alan Roberts, 2012

The right of Alan Roberts to be identified as the
Author of this work has been asserted in accordance
with the Copyrights, Designs and Patents Act 1988.

ISBN 978 1 4456 0914 0

British Library Cataloguing in Publication Data.
A catalogue record for this book is available from
the British Library.

Typeset in 9.5pt on 12pt Celeste.
Typesetting by Amberley Publishing.
Printed in the UK.

Introduction

Matlock is located on the River Derwent in a fairly central position in Derbyshire. At Matlock, the Derwent carves its way through hard limestone rock, creating Matlock Dale, one of Derbyshire's most spectacular dales, with crossing points of the river at each end of the dale, at Matlock and at Cromford.

Matlock Bridge lies on an ancient route much used for the transport of locally mined lead eastwards to Nottingham and beyond. On the eastern side of the Derwent, this route followed the valley of Bentley Brook (a tributary of the Derwent) for the first two miles. Cromford Bridge lies on a route northwards from Wirksworth to Chesterfield, following the general line of a Roman road (later called Hereward Street) which crossed the above route at the area now called Matlock Green.

The old town of Matlock developed on elevated ground above Bentley Brook on the line of Hereward Street, there called Church Road. This area had a church, a small village green, up to five inns at various times, a forge and a corn mill nearby on Bentley Brook.

As late as 1849, the area now known as Matlock consisted mainly of Old Matlock, a scatter of buildings between Matlock Bridge and Matlock Bank, and various farms. In 1849, the extension of the London to Ambergate railway line through Matlock to Rowsley (further extended to Buxton and Manchester in the 1860s) changed all that. With the improved access to the town, Smedley's Hydro, a hydropathic establishment for the treatment of various conditions, developed rapidly from 1853 onwards and many other hydros followed – as many as thirty by the end of the century. As fashions changed, these buildings changed their use; Smedley's Hydro lasted until the 1950s, when Derbyshire County Council bought the buildings to establish their main offices there.

Matlock Dale, in its original state, was only frequented by local inhabitants – lead miners, fishermen, farmers. However, treatments by

mineral water springs became fashionable from the early eighteenth century onwards and treatment baths were established at several springs in the dale. Road access was improved and Matlock Bath grew up on the eastern slopes of Matlock Dale with hotels near the springs and roads climbing the hillside in successions of hairpin bends. Pleasure grounds were opened for visitors to enjoy open air activities and a pavilion was built high on the hillside, replaced by the present Grand Pavilion by the side of the river, in 1910.

Another major change took place in Matlock Dale, following the construction by Richard Arkwright of a large water powered cotton mill at Cromford, generally regarded as the start of the Industrial Revolution. The success of this mill led locally to a second mill at Cromford and one at Masson Mill in Matlock Dale in 1783. The historical importance of these and other mill developments along the Derwent led to the designation of the Derwent Valley World Heritage Site in 2001, most of which is outside the scope of this book. However, the coverage includes three of the sites (in outline only) as it follows the Derwent along to Cromford Bridge.

Recent years have seen more changes in the area. The opening of the cable car to the Heights of Abraham, high above Matlock Dale, not only increases the ease of access to the Heights but also gives passengers a marvellous bird's-eye view of the river valley. The Peak Rail heritage line between Rowsley and Matlock provides an additional interest for visitors. A smart new swimming pool and leisure centre opened in Matlock in 2011, replacing the former Matlock Lido in the town centre. A new road bridge across the Derwent and the building of Derwent Way as a new route for the A6 through Matlock eased traffic congestion in the town centre and gave access for additional parking and a new supermarket.

A major restoration and improvement of the sequence of five parks and open spaces that runs from Hall Leys Park near Matlock Bridge along the banks of the Derwent to Matlock Bath provides riverside walks and a splendid set of views from the high ground above Matlock Dale. In 2012, a major project to renovate Matlock Bath's Grand Pavilion, as a focus for live performances, concerts and art displays in the centre of the town, had its first event and its planned improvements will provide a valuable social asset for the town.

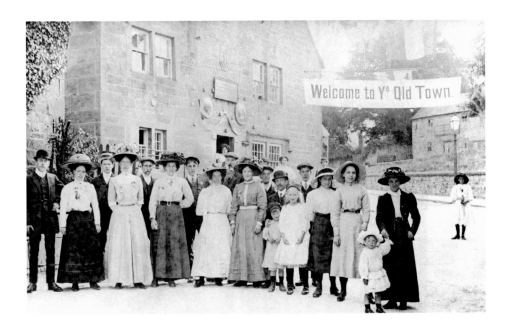

'Welcome to ye Old Town'

The inhabitants of Old Matlock are celebrating the coronation of King George V in June 1911, beneath their banner 'Welcome to Ye Old Town'. The banner is attached to the King's Head, one of the five inns which operated in this immediate area at various times. The lower photograph also shows the King's Head building, which is thought to date from 1628 and is now a private residence, and the grassed area in front of the church.

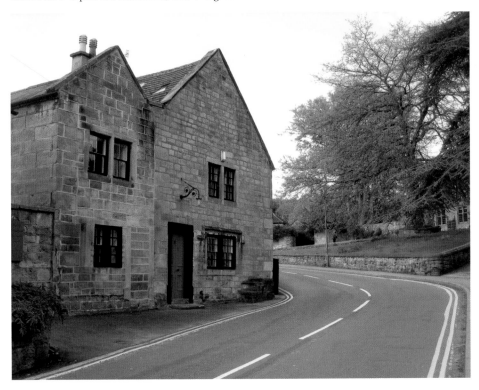

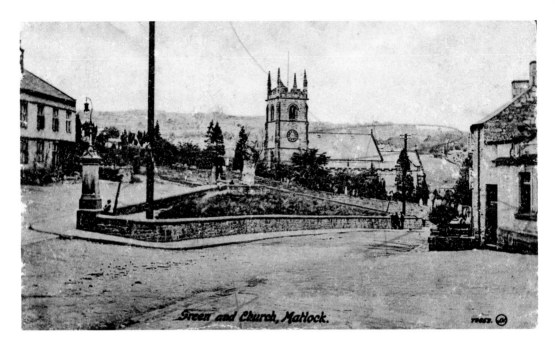

Green and Church, Matlock.

Old Matlock

Old Matlock grew up along the old road from Wirksworth to Chesterfield, with St Giles Church, a small village green, the inns and all the other local facilities of a country village. The lower photograph shows the former Wheatsheaf Inn building on the left and the sign for the Duke William on the right but the view of the church has been blocked by the growth of the trees.

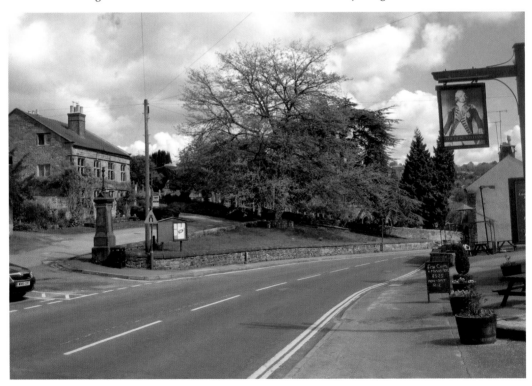

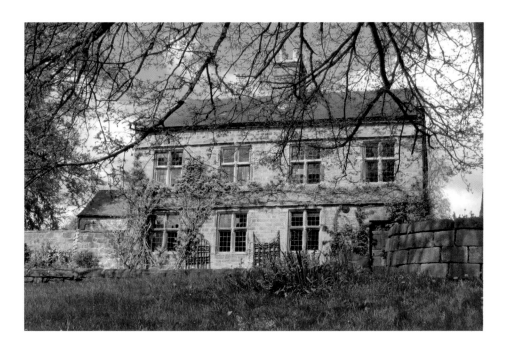

Old Matlock

The Wheatsheaf building (upper photograph) was originally a farmhouse; it has a 1681 date which is thought to relate to the remodelling of the façade. In the late eighteenth century, it became an inn and it is now to a private residence. The Duke William Inn (lower photograph) dates from the late eighteenth century, and was probably named after the Duke of Cumberland. A school was built next door in 1870, which closed in 1992; the building has been converted to apartments. Riber Castle is visible on the skyline.

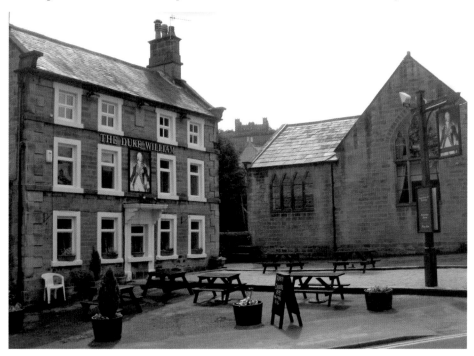

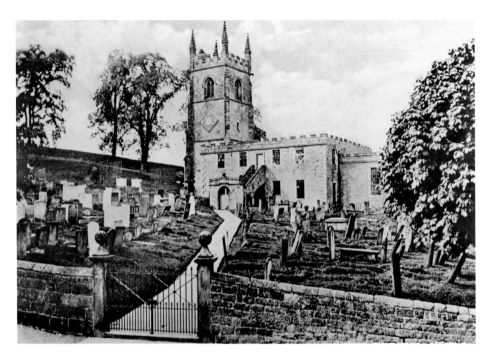

St Giles Church

There has been a church on this site since the twelfth century. The tower of the present building dates back to the fifteenth century. There was substantial rebuilding of the church in the second half of the nineteenth century which, among other things, altered the roof line to the pitched form shown in the lower photograph. The church site, the core of Old Matlock, is at the foot of Pic Tor well above the floodplain of the Derwent, on the eastern side of that river.

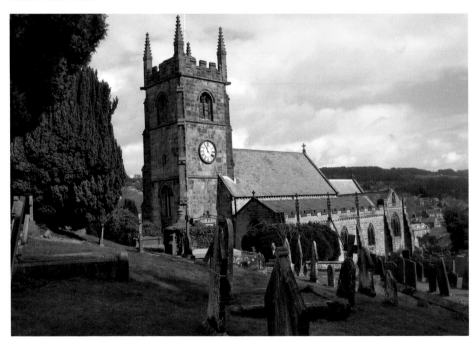

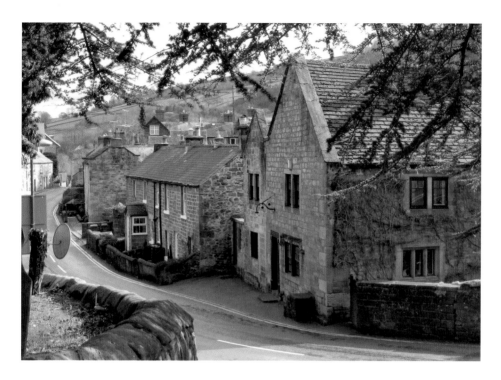

Downhill to Bentley Brook

Church Road (upper photograph) leads down from St Giles to cross Bentley Brook a few hundred yards before that stream joins the Derwent. The lower picture shows the church looking up from the far side of Bentley Brook. The buildings shown near the stream are no longer there and the church is shown with its earlier flat roof.

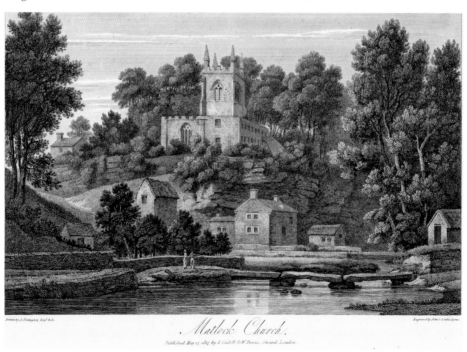

Matlock Church.

Published May 15 1817 by T Cadell & W Davies, Strand, London.

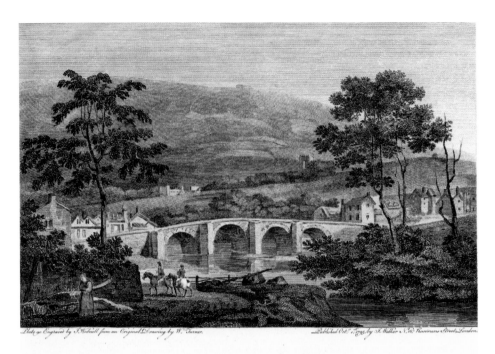

MATLOCK. BRIDGE.

Matlock Bridge

The Domesday Book records a ford at Matlock. The bridge is thought to date from the fifteenth century and it was widened in 1904. It was an important crossing point of the Derwent for the Derbyshire lead industry on a packhorse route from Winster via Snitterton to Nottingham and beyond, which was joined near the bridge by Salters Lane, a route for packhorses carrying salt from Cheshire.

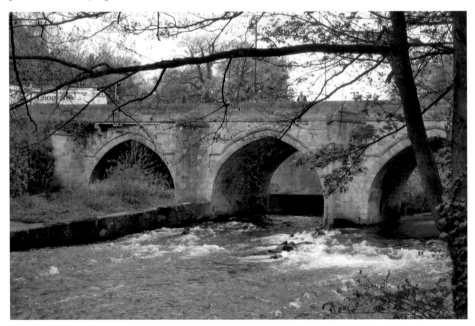

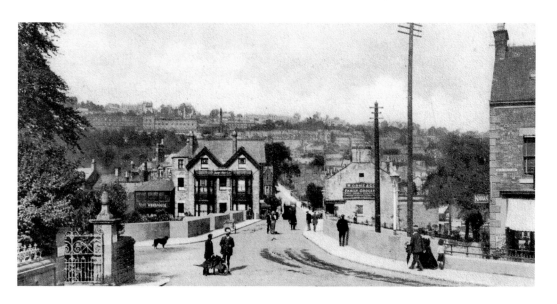

Matlock Bridge and Bakewell Road

Matlock developed mainly on the eastern side of the Derwent (across the bridge, as shown in the upper picture). In the lower photograph, the trees have grown and the road across the bridge is now one way only, following the construction of a second road bridge across the river (page 44). The crowds are gathering for the Olympic Flame to reach Crown Square on its way through Matlock.

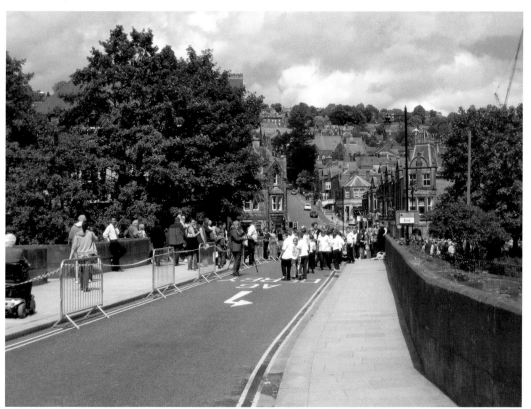

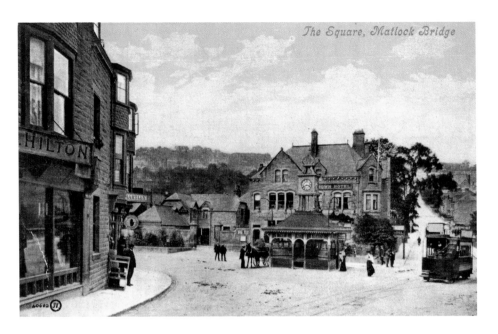

The Square, Matlock Bridge

Crown Square

A short distance from the bridge, Crown Square was, at one time, the terminus for the tramway which ran up Bank Road and the small structure shown in the upper picture was a shelter for passengers waiting for the tram (see pages 21, 24, 25). The most prominent building in Crown Square is the former Crown Hotel, built in 1899 (now occupied by a branch of Britannia Building Society), with Bakewell Road to the left and Bank Road to the right of the building (lower photograph).

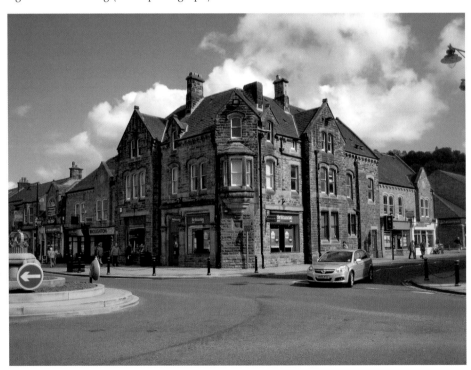

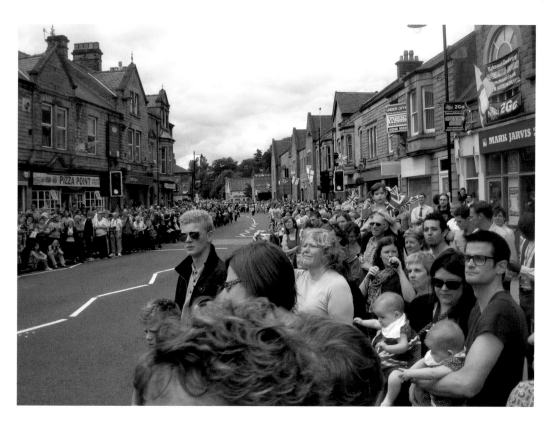

The Olympic Flame

In the run up to the 2012 Olympic Games in London, the Olympic Flame passed through Matlock on 29 June 2012 and large crowds gathered along its route. The upper photograph shows the crowds gathered along Bakewell Road (leading out of Crown Square) and the lower photograph shows the flame being carried through Crown Square in front of an enthusiastic crowd.

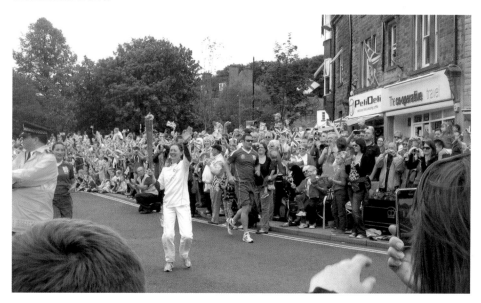

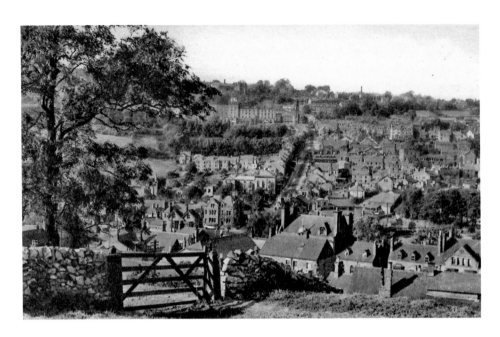

Bank Road

The upper picture shows Bank Road as it leaves Crown Square and climbs steeply to the area known as Matlock Bank. On its way, it passes the offices of no fewer than three layers of local government. In the lower photograph, the building on the left of Bank Road is the former Crown Hotel and on the right is the former Crown Buildings, dated 1889 and decorated by a tower similar to the larger one on Smedley's Hydro.

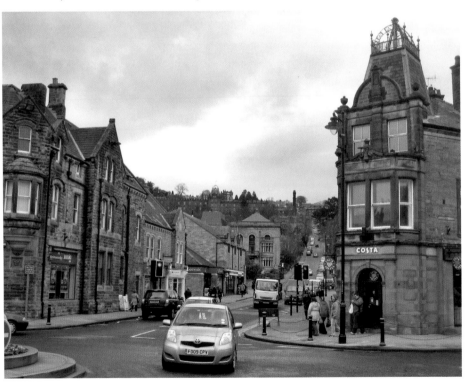

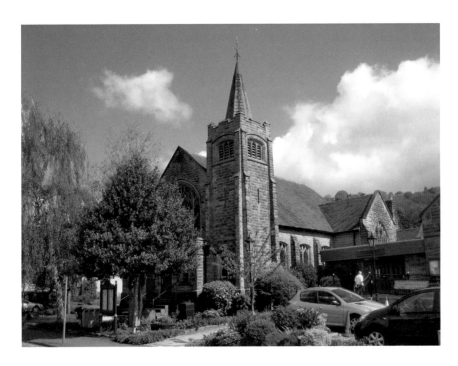

Local Government

Imperial Road leads off from the left-hand side of Bank Road, a short distance up from Crown Square. The offices of Matlock Town Council have been housed in the former Methodist Church in Imperial Road since 1983 (upper photograph). The offices of Derbyshire Dales District Council are in the imposing building on the corner of Imperial Road and Bank Road (lower photograph), originally Bridge Hall Hydro but used as offices by various councils since 1894, with several extensions, most recently in 1979.

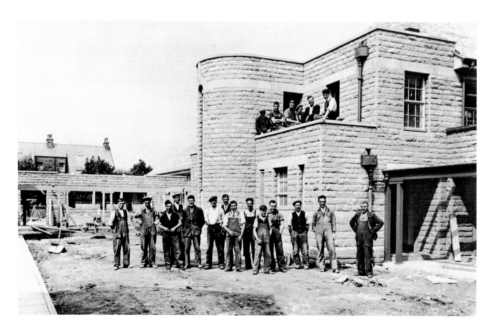

Matlock Lido

Matlock Lido was constructed in 1938, opposite the Methodist Church in Imperial Road, as an open air swimming pool with a smaller covered pool. After various changes, including roofing it over, it was demolished in 2012 and the site, for the time being, will be used as a car park. The upper picture shows the construction of the lido and the lower photograph shows 'demolition in progress'.

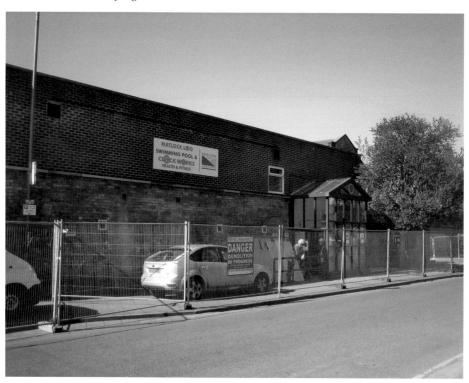

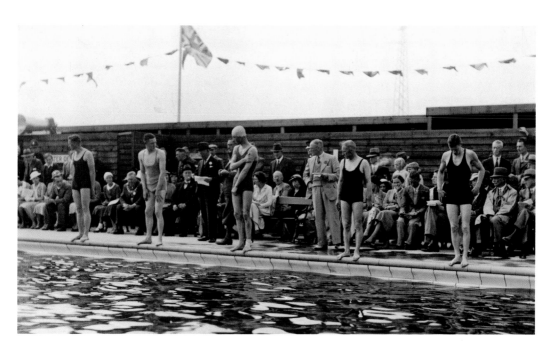

The New Leisure Centre

The upper photograph shows the lido in its open air days while the lower photograph shows the smart new leisure centre, incorporating an eight lane 25-metre swimming pool, which opened in 2011. This facility is located a short distance along Bakewell Road.

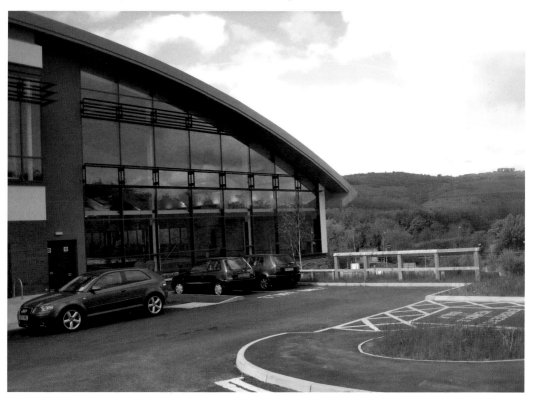

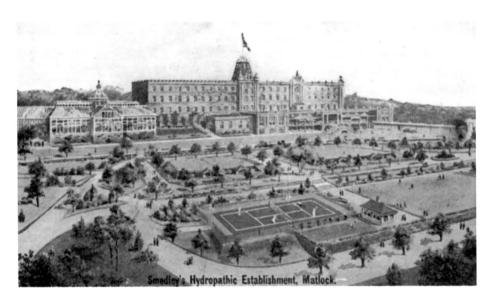

Smedley's Hydropathic Establishment, Matlock.

Smedley's Hydro

John Smedley was a successful local businessman who was impressed by the health benefits that he experienced at a spa treatment in Ilkley. After a smaller scale venture, he set up the first Smedley's Hydro in 1853 on a large site at Matlock Bank, adjoining Bank Road. As well as hydropathic treatments, the Hydro provided an extensive range of outdoor activities and gardens, as shown in the upper photograph.

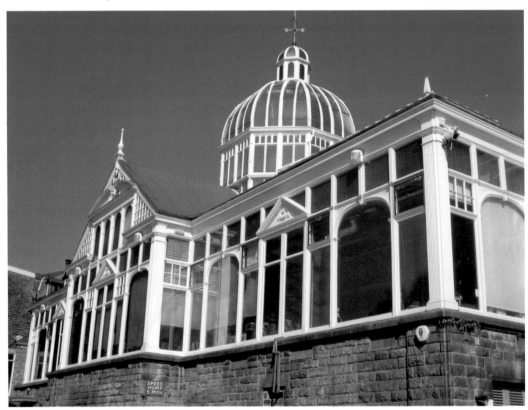

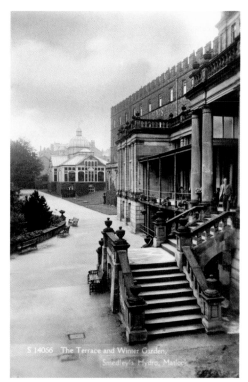

Smedley's Hydro

The buildings were extended several times. The main building had an elaborate façade which can be seen in the upper picture of page 18 and the lower picture of page 19 and a Winter Garden (lower photograph page 18 and upper photograph page 19). The scale and location of the Hydro made it the most prominent building in Matlock.

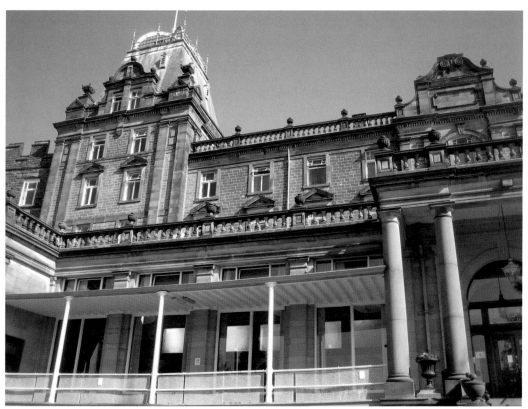

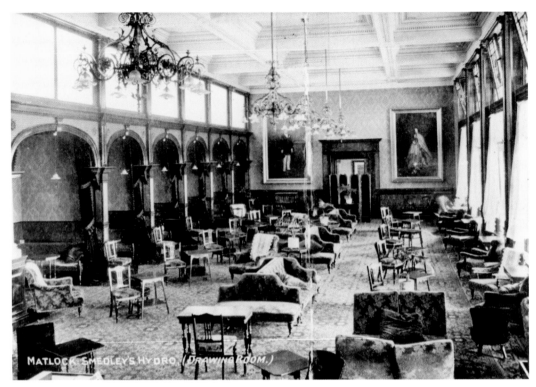

MATLOCK SMEDLEY'S HYDRO. (*DRAWING ROOM.*)

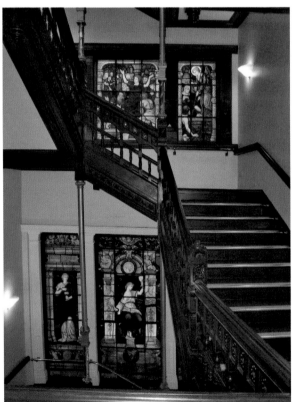

Smedley's Hydro

The upper photograph shows the Drawing Room of the Hydro, now the Members Room for county councillors, while the lower photograph shows the main staircase and the elaborate stained glass windows, depicting themes relating to health, medicine, fresh air and exercise, at three different floor levels. These windows were paid for by public subscription in the 1880s.

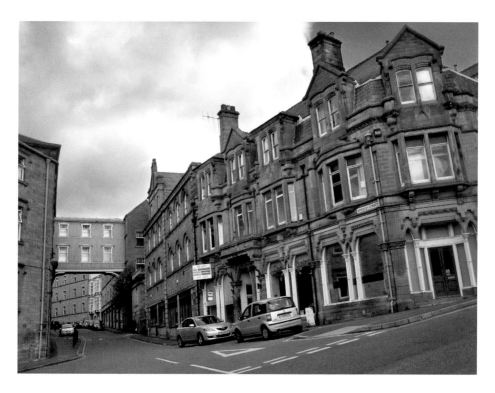

Smedley Street and the Tram

In the upper photograph, at the junction of Smedley Street with Bank Road, the original Smedley's Hydro is to the left while the bridge across the road links it to the North Block of the hydro complex, constructed in 1877. The Hydro remained in use until the 1950s when the buildings were purchased by Derbyshire County Council for their head offices. The lower photograph shows two trams passing at the same road junction.

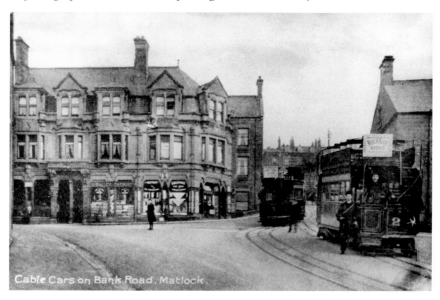

Cable Cars on Bank Road, Matlock.

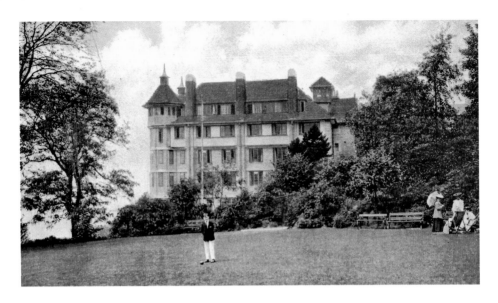

Rockside Hydro

Following the success of Smedley's Hydro, many other hydros were opened in Matlock. One of these was Rockside Hydro (1862) located higher up on Matlock Bank than Smedley's Hydro and standing out prominently on the skyline. It had luxurious accommodation and facilities, together with attractive grounds, which included tennis and croquet courts.

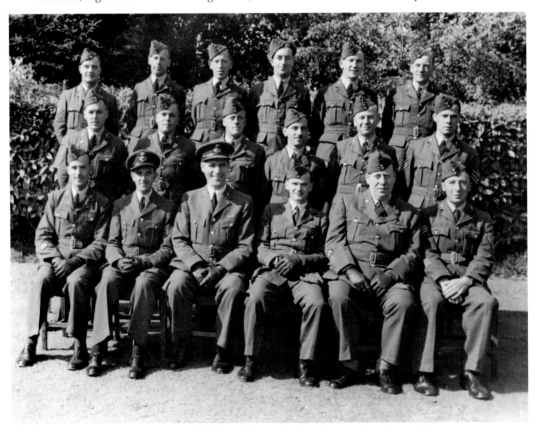

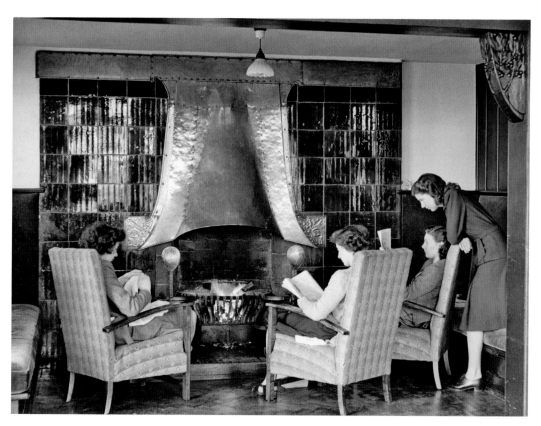

Rockside Hydro

During the Second World War, Rockside Hydro was used as a military hospital for RAF personnel (lower photograph page 22) and after the war it was used as Matlock Teacher Training College (upper photograph). When this college closed in 1988, the building stood empty for some years but in 2004/05 it was fully restored and extended for use as apartments.

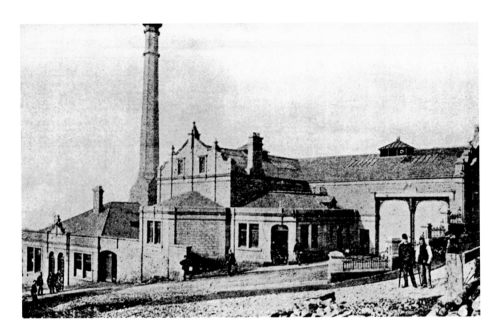

The Tramway Terminus

George Newnes, a famous publisher and a native of Matlock Bath, was inspired by the sight of cable operated trams on the steep streets of San Francisco and promoted the construction of the Matlock system, running up Bank Road from Crown Square to the terminus building shown in the upper photograph. The tramway opened in 1893 and closed in 1927. The terminus building, minus its chimney, (lower photograph) is now a garage.

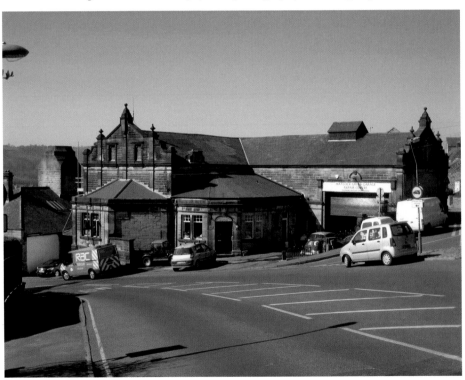

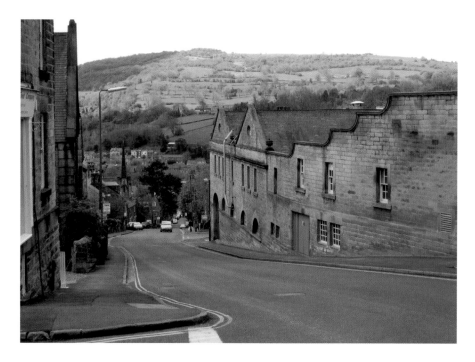

Downhill to Crown Square

Looking down Bank Road, past the side of the Smedley's Hydro boiler house, the upper photograph shows how steep the ascent of Bank Road is. No doubt, many people were glad to ride the tram rather than walk up Bank Road. As a comparison of the photographs on page 12 shows, the tram shelter is no longer in Crown Square – it was reconstructed in nearby Hall Leys Park (lower photograph).

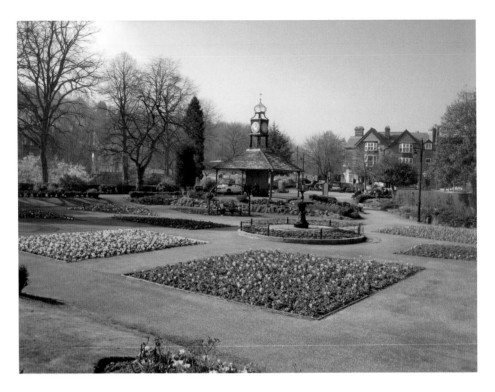

Hall Leys Park

Causeway Lane is the third road radiating out from Crown Square and Hall Leys Park was laid out between Causeway Lane and the Derwent, stretching from Crown Square to Knowleston Terrace. This park was officially opened in 1911 to celebrate the coronation of King George V. The part of the park nearest to Crown Square is laid out with attractively planted flower beds where the tram shelter now stands.

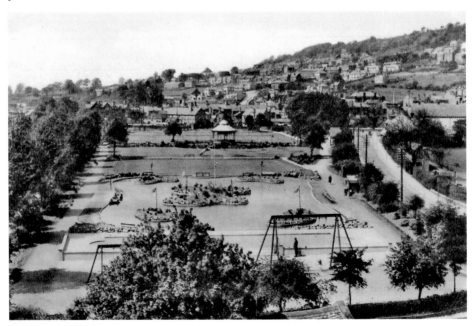

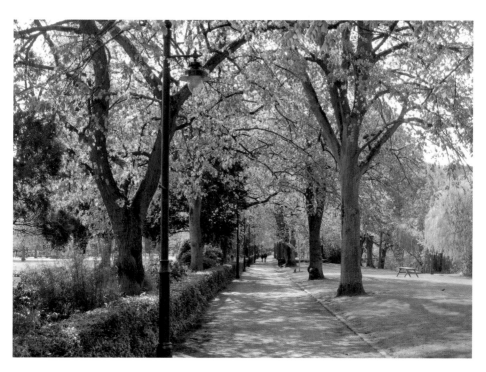

Hall Leys Park

On the left of the lower photograph on page 26, the avenue of trees runs along the bank of the Derwent and these trees still provide an attractive shady walk with views of the river. The bandstand in that photograph also still provides an attractive centre point for the park.

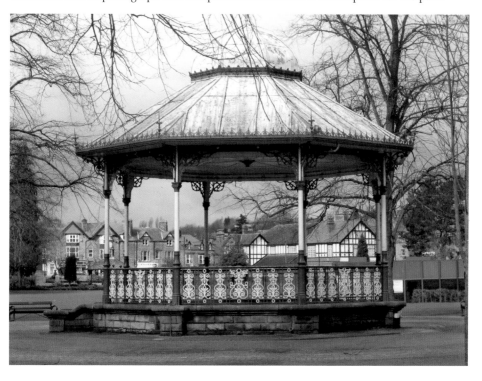

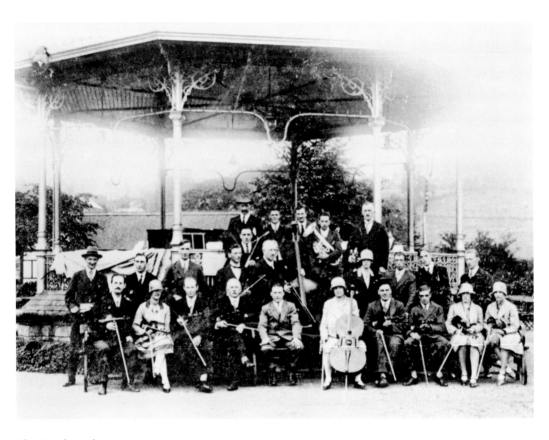

The Bandstand

The upper photograph shows the Matlock Brotherhood Orchestra in 1920, while the lower photograph shows a different aspect of the bandstand from many years ago.

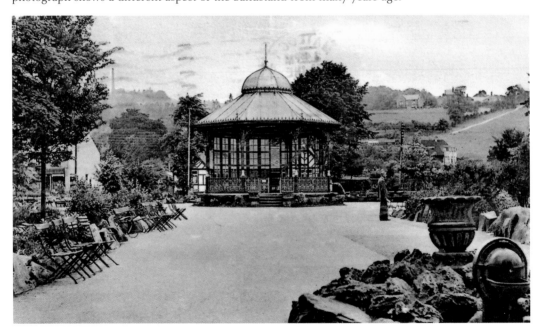

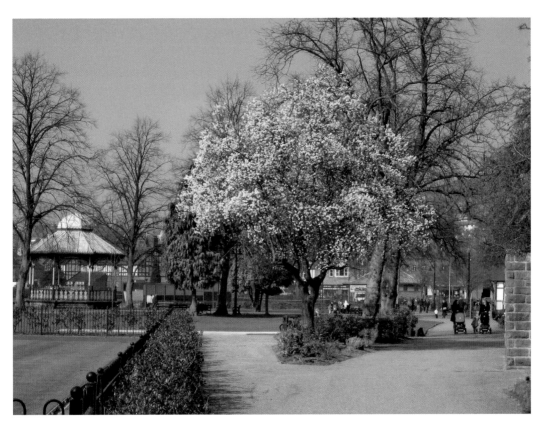

Views of the Park
The park provides an area for pleasant family outings, with its café, tennis courts, model train ride, boating lake and skateboard park, in a setting of flower beds and flowering trees.

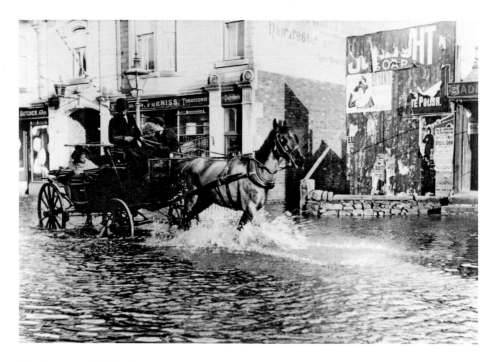

The Derwent in Flood

Over the centuries, the Derwent has been prone to flooding which is why the older routes took a higher level route where possible. Particularly severe floods were recorded in 1881 when parts of the Derwent Valley were described as resembling an inland sea. The upper photograph shows flooding in 1907 while the lower photograph shows Crown Square flooded in May 1966. Improvements to flood defences were made in the 1970s, including lowering the bed of the Derwent.

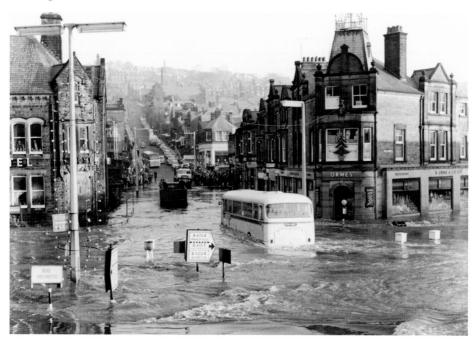

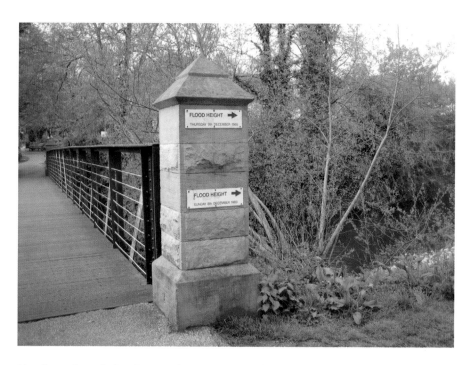

Flood Levels and Flood Control

Hall Leys Park is part of the floodplain of the Derwent, as shown by the signs on the footbridge recording flood levels for 1960 and 1965. The park is now part of the flood defences of Matlock, surrounded by a wall to contain flood water, as shown in the lower photograph. The entrances to the park are elevated above park level except for this one on Causeway Lane which has a door which can be closed in the event of a flood occurring.

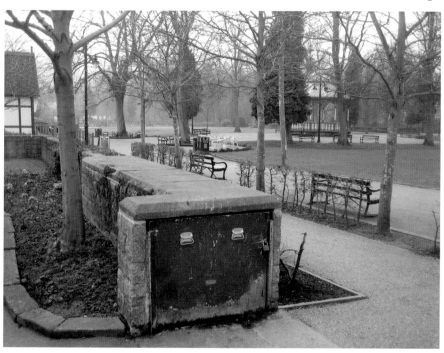

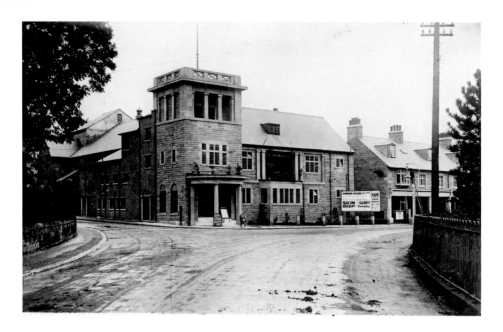

The Old Cinema

One of Matlock's two cinemas was located on Causeway Lane, at the corner with Steep Turnpike. This cinema, the Ritz, opened in 1920 and closed in 1999 (upper photograph, 1922). The building is now used for shops and offices, with a decorative car mounted above the main entrance. Steep Turnpike was a continuation of the Wirksworth/Chesterfield route from Willersley but the favoured route up to Chesterfield is now along the slightly less steep Lime Tree Road, further along Causeway Lane.

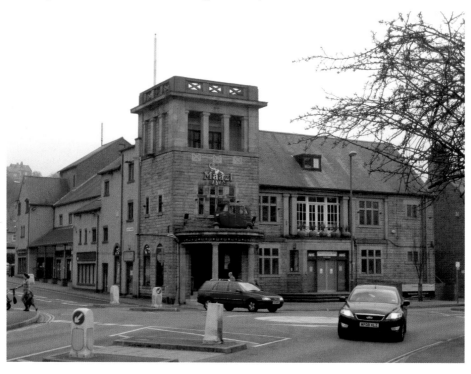

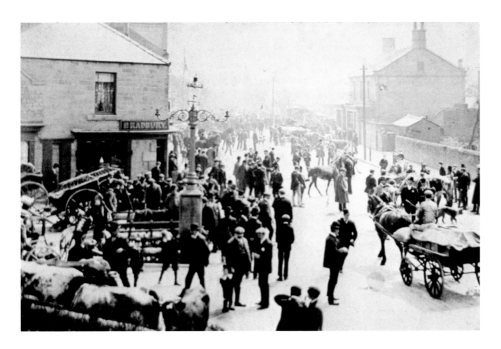

Causeway Lane

Causeway Lane leads on to Matlock Green and is part of the old route from Matlock Bridge towards Nottingham. Being on the edge of the floodplain of the Derwent, it was raised on to higher foundations in the mid-nineteenth century. The upper photograph shows a horse fair in progress at Matlock Green in the 1900s, while modern excitement is provided by the Matlock Town Football Club ground, across the road from Hall Leys Park.

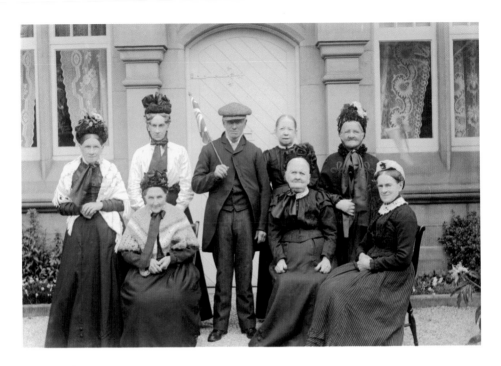

The Almshouses

The foundation stone for these almshouses in Matlock Green was laid on the day of Queen Victoria's Diamond Jubilee in 1897 and the upper photograph was taken in 1904. They consisted of six units 'to provide rest for the aged poor'. From the outside, the almshouses look much the same today, although they have been updated internally.

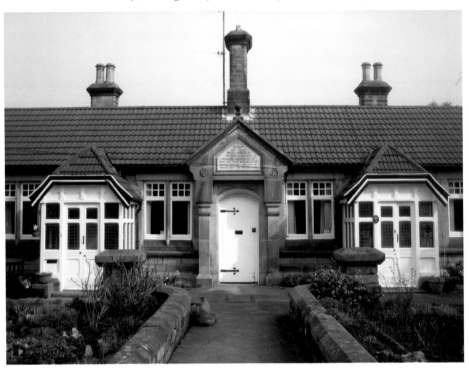

Knowleston Place and Bentley Brook

In Knowleston Place is a terrace of houses built by John Knowles in 1857 with a striking stone obelisk in front of one of the houses (upper photograph) and adjoining older properties dating from 1621 and 1753. The terrace, facing on to Bentley Brook (lower photograph), is located just beyond Hall Leys Park. Here, the brook flows by the side of Hall Leys Park and Knowleston Gardens towards the Derwent, a short distance away, in a reasonably scenic setting.

Changing House Styles

Further along Matlock Green is a pair of cottages built by Joseph Paxton, shown in the upper photograph. In a contrasting style, on the opposite side of the road, is a pair of semi-detached houses in a style more reminiscent of the 1930s art deco style.

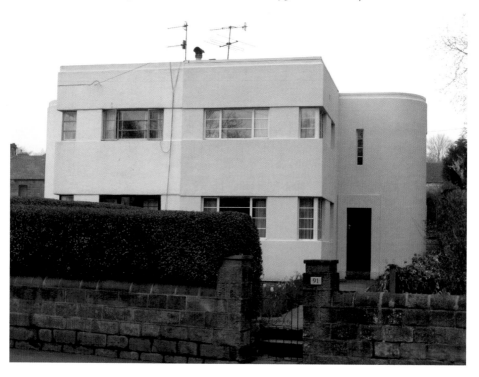

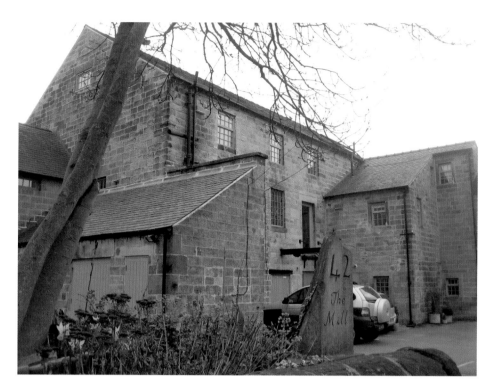

Matlock Corn Mill

Like any other medieval village, Old Matlock had a corn mill, dating back to at least 1374, probably located on Bentley Brook close to the site of the mill building shown in the upper photograph. The water-powered mill on this site was rebuilt by Ernest Bailey and it continued operating until 1938. After a period of use as laboratories, it was renovated and converted into apartments. The brook has a more utilitarian appearance in this area (lower photograph).

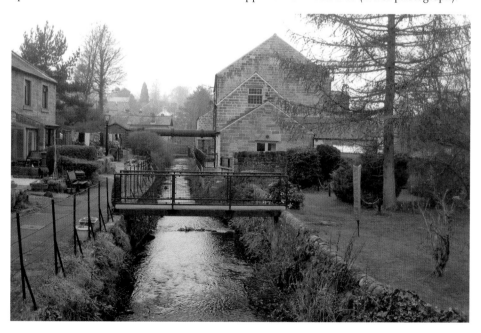

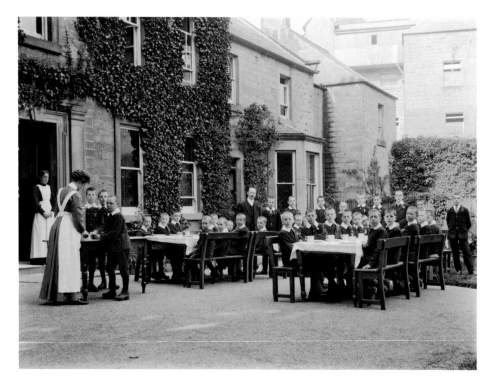

The Higher Corn Mill and Lumsdale

A second, much larger, corn mill was constructed a short distance further along Bentley Brook in the late eighteenth century. Part of this mill was converted for use as a Boys' Home in 1901 and named St Andrews House (see upper photograph) but milling continued until 1944 in other parts of the building. This set of buildings has also been converted to apartments. From here, a minor road leads up into Lumsdale and its many mill sites, one of which, Garton's Mill, is shown in the lower photograph.

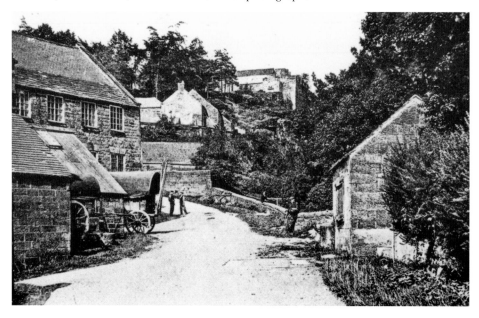

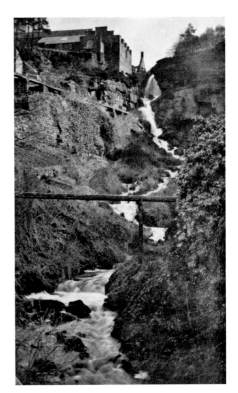

Lumsdale

From Bentley Bridge on the Chesterfield Road to the mill shown on page 38, Bentley Brook makes a remarkable 100 metre descent through the narrow valley, Lumsdale. In this journey it was used to power no fewer than six mills dating back to the 1600s, for a wide variety of industrial purposes as well as grinding corn. The site of this remarkable piece of industrial archaeology is now conserved by the Arkwright Society and tours of the sites are held several times per year.

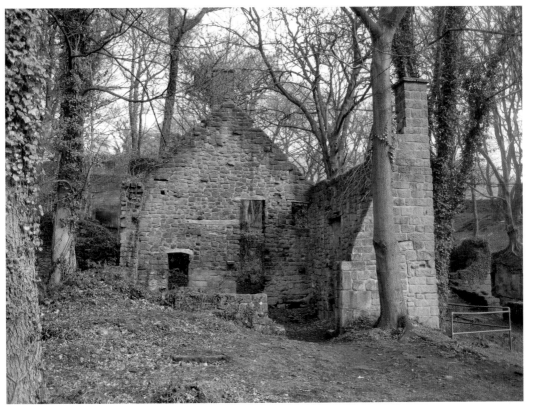

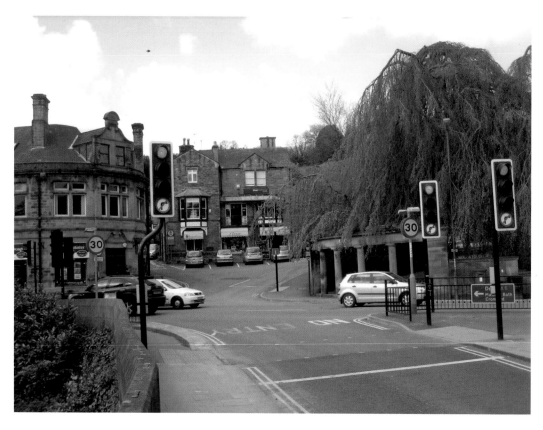

Matlock Bridge and Dale Road

On the western side of the Derwent, there are four roads radiating out from Matlock Bridge. In the upper photograph, the road to the left is Dale Road, the A6 heading south, while the road to the right is the newly constructed Derwent Way, now the A6 heading north. Straight ahead is a florists shop, in the former post office building. To the left of the florists is Holt Lane while to the right is Snitterton Road. Dale Road is also shown below.

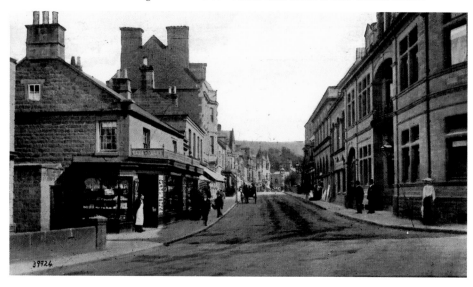

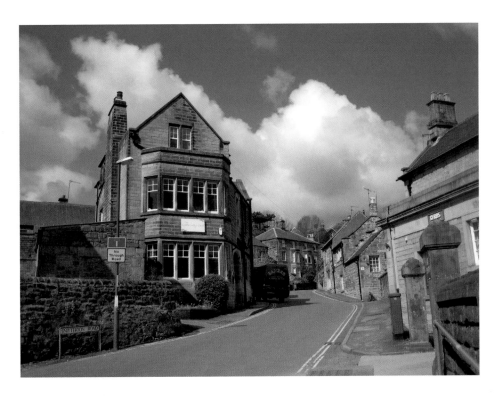

Snitterton Road

Holt Lane is an older route leading towards Matlock Dale at a higher level than Dale Road. Snitterton Road (upper photograph) leads through the small village of Snitterton to Wensley and Winster, a route for the transport eastwards of Derbyshire lead. Snitterton Hall, which dates back to the Elizabethan period, is shown in the lower photograph.

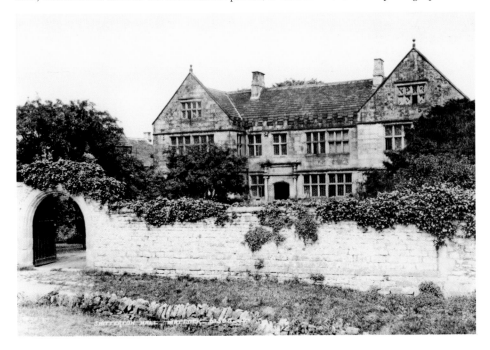

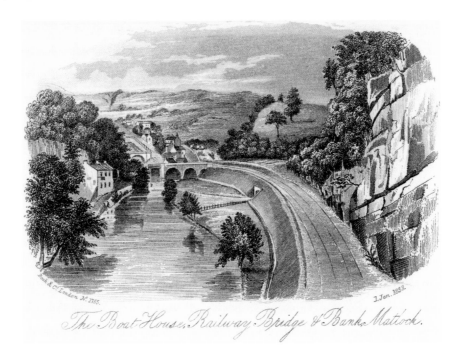

The Boat House, Railway Bridge & Bank, Matlock.

The Coming of the Railway

Matlock Station was opened in 1849, close to Matlock Bridge, as part of the extension northwards of the line from London to Ambergate, which was further extended to Buxton and Manchester in the 1860s. The upper picture shows the railway line crossing the Derwent at the northern end of Matlock Dale, the bridge over Dale Road, the Boathouse Inn and a tunnel entrance. Matlock Station (lower photograph) is near the further end of that tunnel.

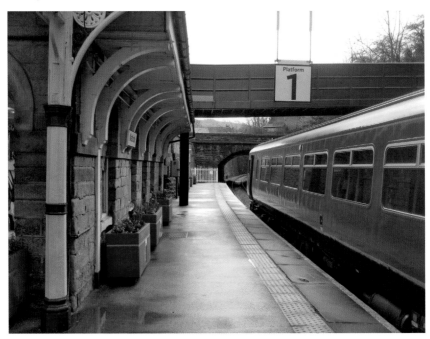

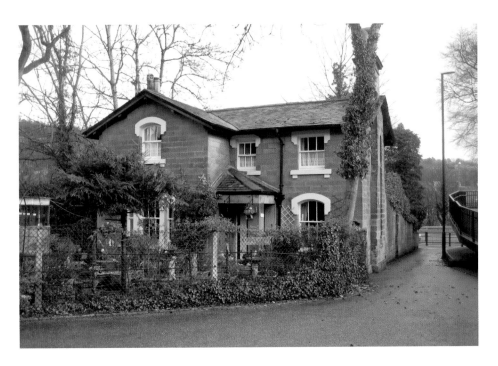

Matlock Station

The elegant Station Master's House at this station was built by Paxton (upper photograph). In 1968, the lines north from Matlock were closed to all traffic. Peak Rail was set up to establish a heritage line along parts of the disused tracks and, for many years, a limited passenger service with steam-powered locomotives operated between Rowsley and a temporary station, Matlock Riverside. This service has recently been extended into Matlock Station itself (lower photograph).

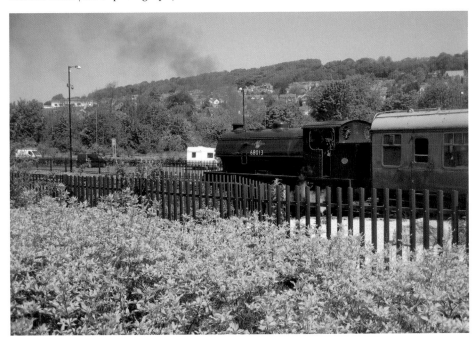

Derwent Way: Two New Bridges

A major change took place in Matlock's road system when a new bridge across the Derwent (of rather utilitarian design) was opened in 2007 and Derwent Way was built connecting this bridge (upper photograph) to Dale Road. A second bridge was built across the railway lines (lower photograph) to open up a new commercial area on the site of the former Cawdor Quarry. Derwent Way was designated as the A6 and the traffic flow through Crown Square was reduced.

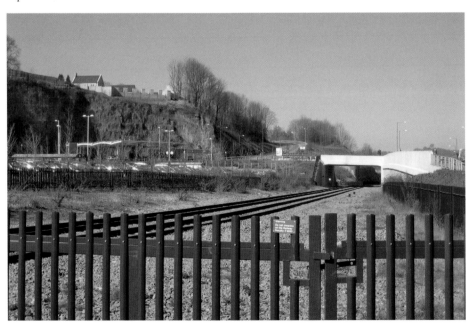

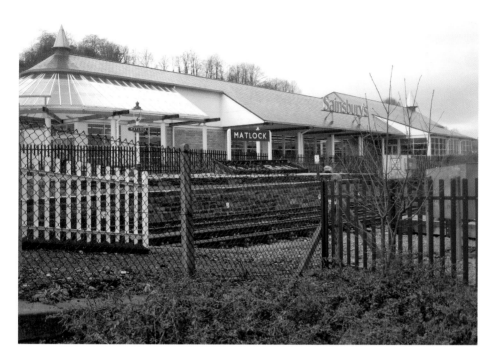

Derwent Way: Other Changes

Sainsbury's supermarket, with a large car park, was built on this newly accessible land, next to Matlock Station (upper photograph). A new road, Matlock Spa Road (visible in the lower photograph on page 44), was built from the second bridge to a higher level of Snitterton Road and the original road was blocked to through traffic (lower photograph).

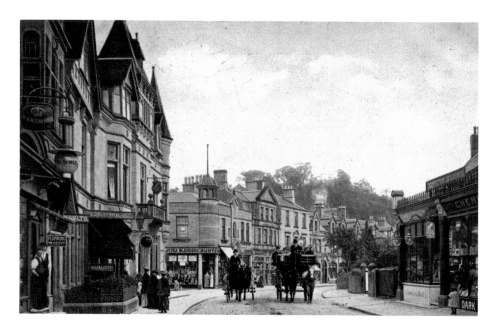

Dale Road

Dale Road was constructed to provide a better route between Matlock Bridge and Matlock Bath, as an alternative to the narrow hilly route provided by Holt Lane. In 1849, when the railway station opened, Dale Road was free of buildings except for a few near to Matlock Bridge but, as Matlock grew, Dale Road filled with shops, hotels, a market hall and, in due course, a cinema.

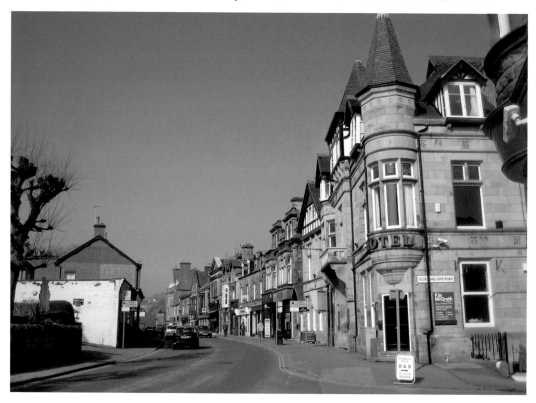

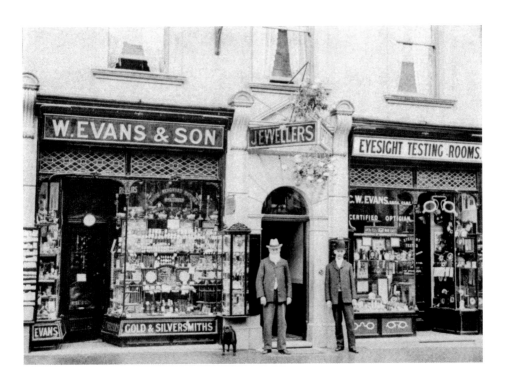

Dale Road

The Olde English Hotel remains a prominent feature of Dale Road, as seen in the photographs on page 46. Evans, the jewellers, established in 1893, still remains in business but the former cinema is now an auction house and the former market hall is now a shop.

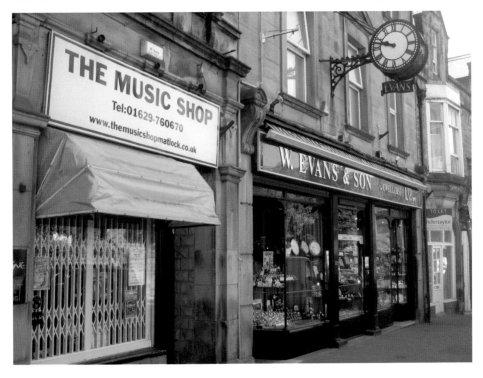

Pic Tor Promenade

At the far end of Hall Leys Park, a footbridge over Bentley Brook leads on to the Pic Tor promenade (lower photograph), a picturesque walk past the foot of Pic Tor, leading into Matlock Dale. The shafts of old lead mines can be seen in these cliffs. The upper photograph shows the beginning of this promenade and a flood barrier that prevents floodwater in the Derwent backing up into Bentley Brook.

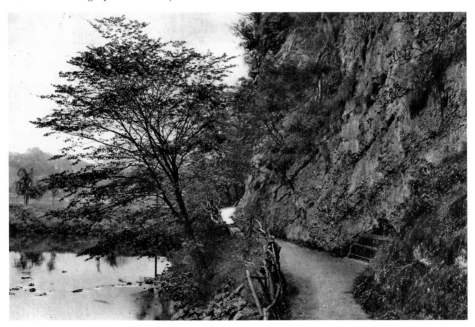

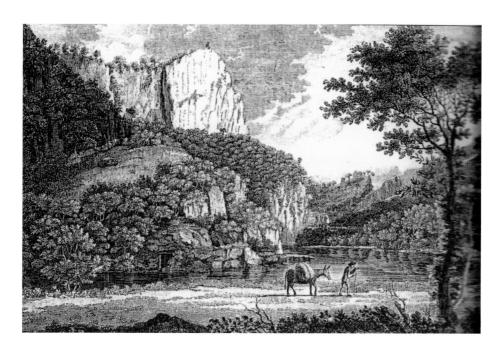

Matlock Dale

Entering into Matlock Dale, the impressive cliffs of High Tor rise up above the left bank of the river. These views and other similar ones along the dale earned the area the description 'Little Switzerland' in Victorian times, when High Tor was developed as a pleasure ground for excursions with an entry point near to Old Matlock and Pic Tor, for walkers and horse drawn carriages (lower photograph).

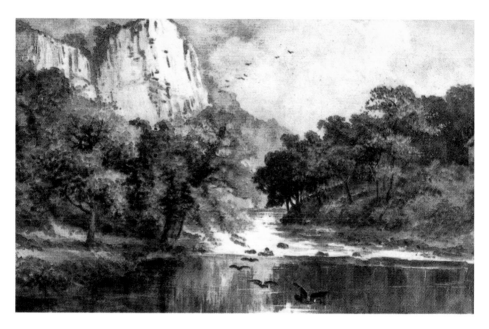

High Tor

High Tor became a prominent feature of many landscape paintings, at different times of the year. In the lower photograph, taken from the Heights of Abraham on the other side of Matlock Dale, the cliff face of High Tor can be seen with a distant view of Matlock in the background. One of the main walks is along that cliff edge with spectacular views down into the dale and elsewhere.

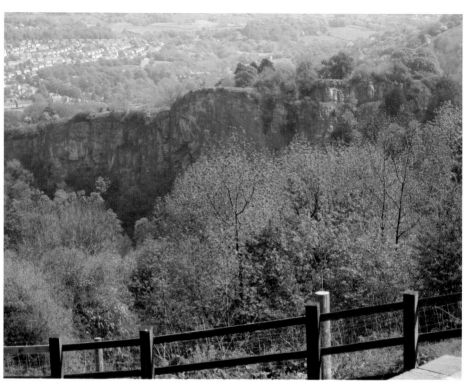

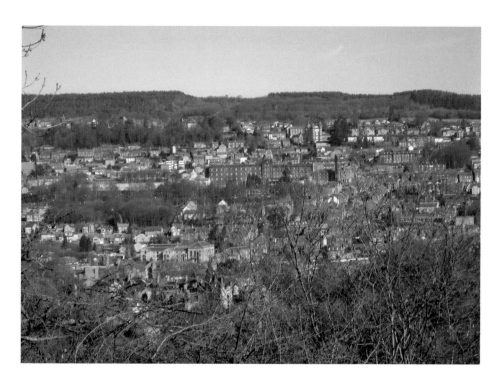

High Tor

The upper photograph shows the view of Matlock from the high level path along High Tor. The lower picture shows a general view of this part of the dale, with High Tor on the left and the Derwent winding its way along the valley bottom. The main road through the narrow dale (A6) runs along the western bank of the Derwent and it has required appreciable removal of stone in places along the dale to achieve the present width for the road.

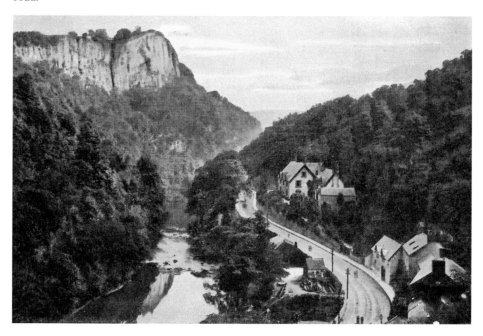

'Artists Corner'

The popularity with artists of the main viewpoint for High Tor led to the name 'Artists' Corner' being used for this area. In the upper picture (probably from around 1880), the toll gate for the turnpike road through the dale can be seen in use on the right-hand side of the picture. In the lower photograph, the houses and the wall in front of them look substantially unchanged, except for the toll bar cottage at the right-hand edge. The road has been appreciably widened.

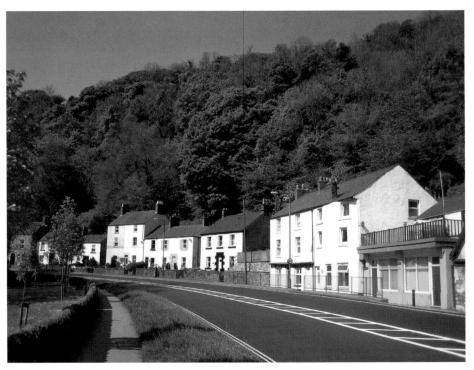

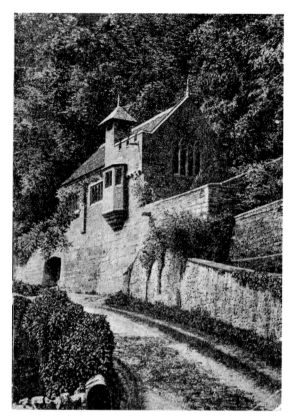

St John's Chapel

This chapel, on St John's Road, is tucked well in against the hillside. It was built in 1897 in the Arts and Crafts style. Unavailable for a visit at the time of writing, it was cocooned in a cover of scaffolding and plastic sheeting for a major renovation. However, it began to emerge from its cocoon in June 2012 (lower photograph) and should be open again soon.

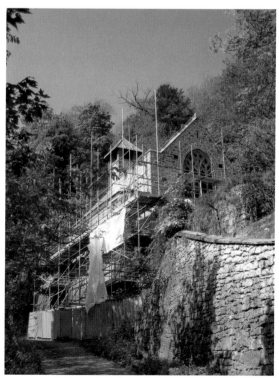

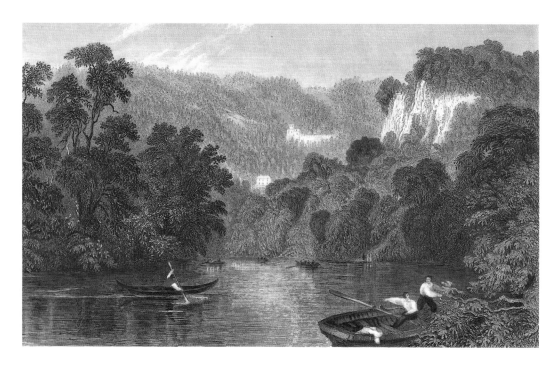

Canoeing on the Derwent

Canoeing on the Derwent at Matlock Bath has been a popular activity for many years. The sport received a boost when the present canoe slalom course (lower photograph) was created in the 1970s on a 100 yard stretch of the Derwent downstream from Artists' Corner. After a local weir was removed as part of a flood prevention scheme for Matlock, a temporary track was laid in the river channel to give access for diggers and other equipment to create the course.

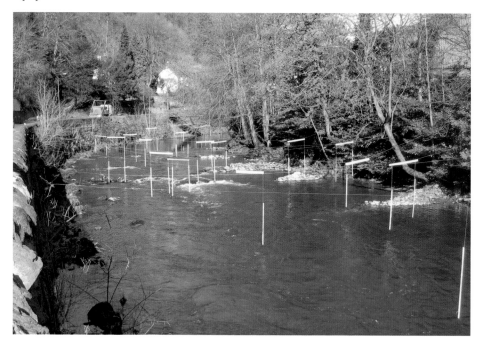

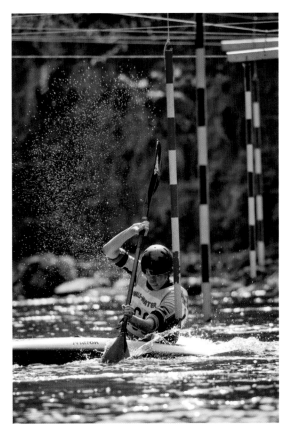

The Canoe Slalom Course
The slalom course has proved very successful and each year in April, it hosts a national slalom event (upper photograph, 2011), attracting around 200 competitors from around the country. In the lower photograph, the bird's-eye view of the course is taken from the cable car to the Heights of Abraham.

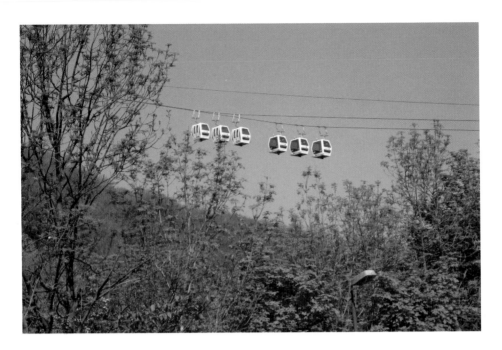

Transport to the Heights of Abraham

The Heights of Abraham were opened as a visitor attraction in 1780, with impressive views across Matlock Dale, after landscaping to minimise the impact of earlier lead mining. Because of its height above the valley floor, access was always a problem but a major change took place in 1984 when the cable car was built with a base station near Matlock Bath railway station. The cable car journey gives extensive views along Matlock Dale.

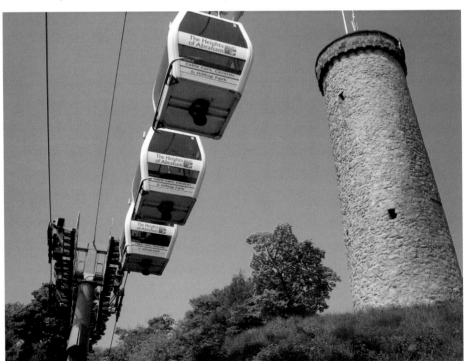

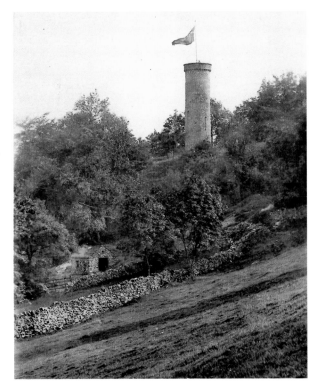

The Heights of Abraham

The cable car (the first such facility in Britain) proved very popular and the site today has a café with a superb view over the dale and several informative displays. The Rutland Cavern and the Masson Cavern, part of the extensive Nessus lead mine, are available for underground tours. The Prospect Tower, built in 1844 as a view point, is still in use today (upper picture). Areas of old spoil heaps from the mines have recently been transformed by clever landscaping, with a sequence of waterfalls (lower photograph).

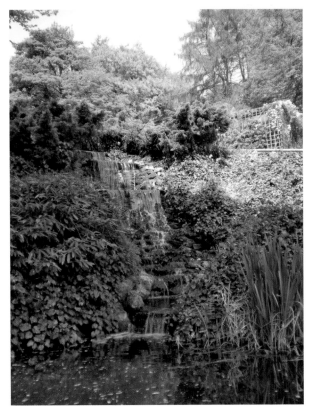

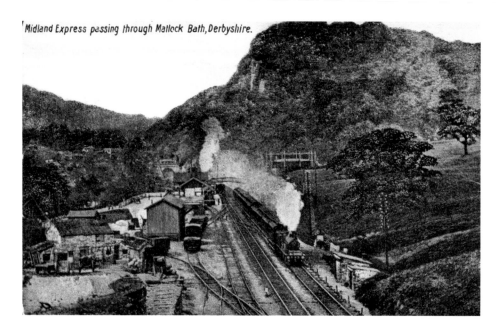

Midland Express passing through Matlock Bath, Derbyshire.

Matlock Bath Station

The railway line from Matlock passes through various tunnels on its way south. Matlock Bath station was built near to one of the tunnel entrances, on the eastern bank of the Derwent, with a road bridge connection to the main road along the dale. The upper picture shows the Midland Express passing through the station (1930s) while the lower photograph shows the Swiss chalet style station building (which replaced an earlier building) as it is today. This building is now used by the Derbyshire Wildlife Trust.

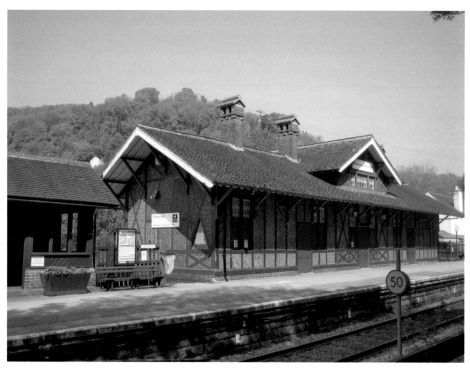

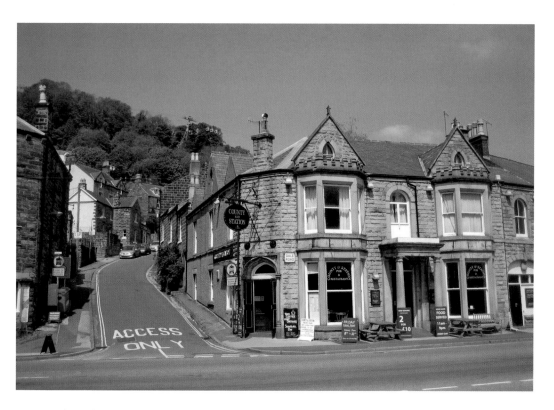

Back to the West Bank

The upper photograph shows the appropriately named County and Station Inn, across the A6 road from the access road to the station. The area close to the station has been tidied up and this access road also leads to a car park for the cable car and Matlock Bath generally. The lower picture shows a view of Matlock Bath from the high ground above the station, including Prospect Tower on the skyline, with North Parade and the above inn in the bottom left-hand corner.

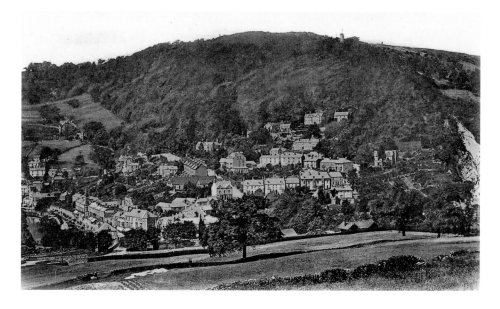

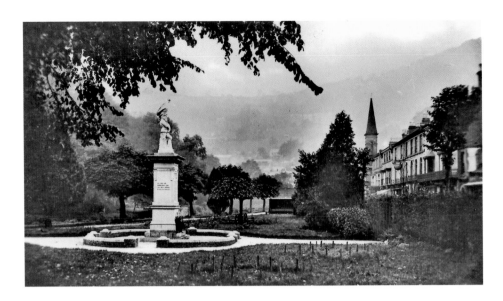

Memorial Gardens

These gardens, running along by the side of the Derwent just south of that access road, were originally known as Derwent Gardens. When the War Memorial was erected, after the First World War, the name was changed to Memorial Gardens. The statue on top of the memorial is skilfully carved in Carrara marble and still looks fresh and crisp in outline nearly one hundred years later. The gardens are noticeably narrower in the lower photograph due to road widening.

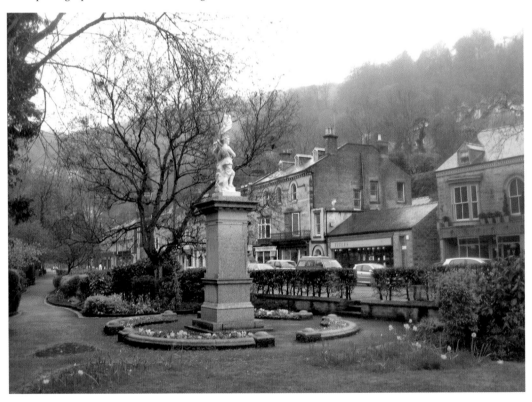

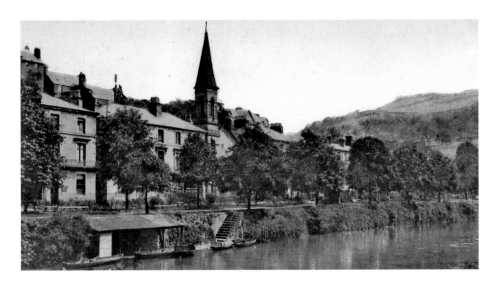

North Parade

North Parade has an elegant array of three-storey buildings facing on to the river on the other side of the road. The prominent spire belongs to the former Methodist church of Matlock Bath which is currently being advertised as a retail space available for rental. The landing point for one of the ferries that used to operate across the Derwent can be seen in the upper picture.

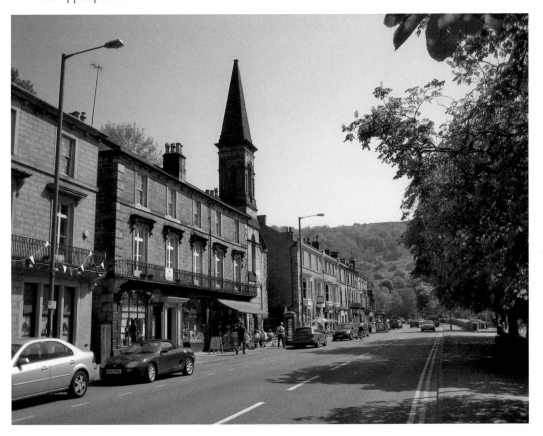

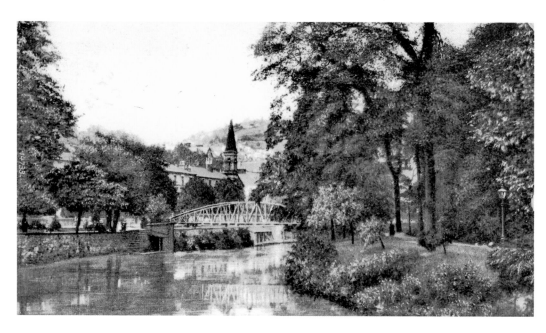

The Jubilee Bridge

These pictures show the bridge built to commemorate the Diamond Jubilee of Queen Victoria in 1897, located just downstream from the former church in North Parade. The bridge leads across to the riverside section of the paths around Lovers' Walks and is still popular today.

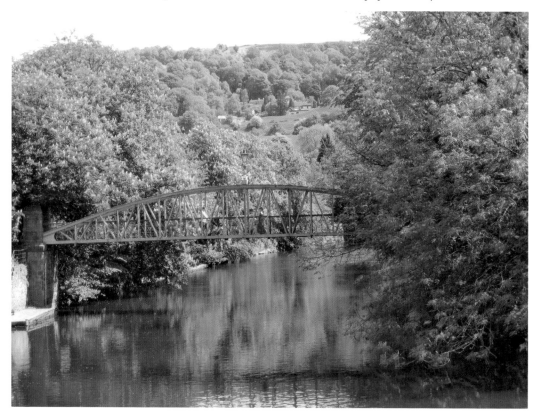

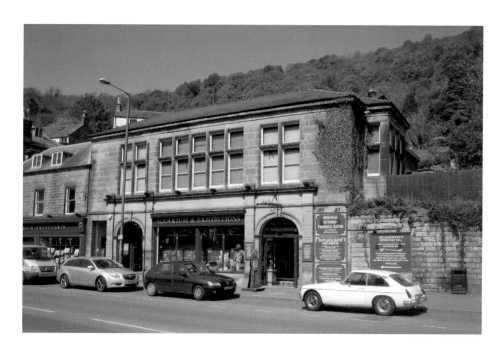

The Matlock Bath Aquarium

The building shown in the upper photograph was formerly the Matlock Bath Hydro (1883) and it now houses the Aquarium. The thermal pool, where treatments took place, now accommodates a large collection of fish. The baths were fed by a natural spring which was also used for a petrifying well and there is a display of petrified objects in the building (lower photograph).

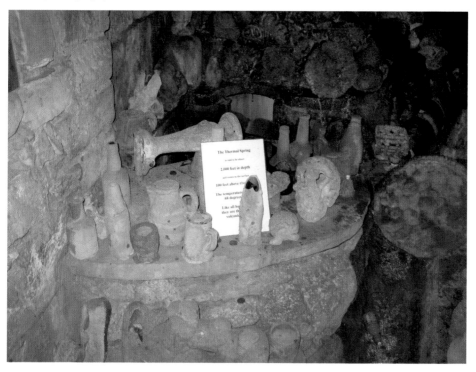

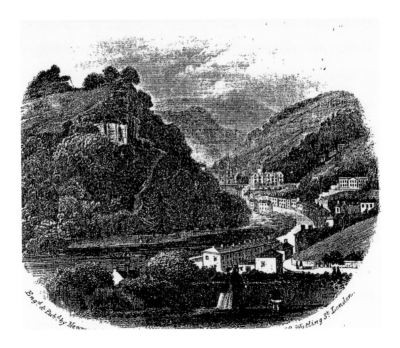

Matlock Bath from Above

Views of Matlock Bath taken from higher levels and looking down into the dale were a popular subject for artists and many different prints were made of these subjects. This pair of pictures show views looking south towards where the Grand Pavilion now stands. The lower photograph demonstrates the increase in housing and tree cover since the upper picture was taken (1880s).

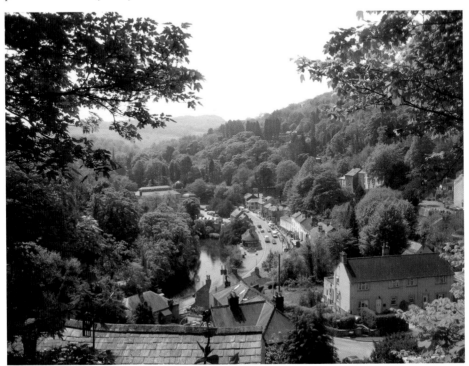

Matlock Bath from Above

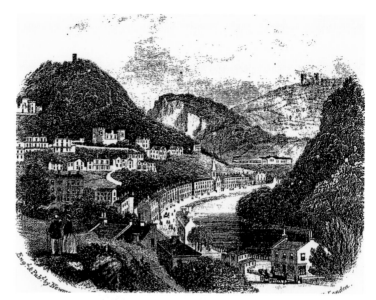

This pair of pictures shows views looking north towards North Parade. The upper picture shows Prospect Tower on the Heights of Abraham and, somewhat imaginatively, Matlock Bath railway station (complete with train) and High Tor. The lower photograph again demonstrates the increase in tree cover. It also shows the Jubilee Bridge erected to commemorate Queen Victoria's Diamond Jubilee in 1897.

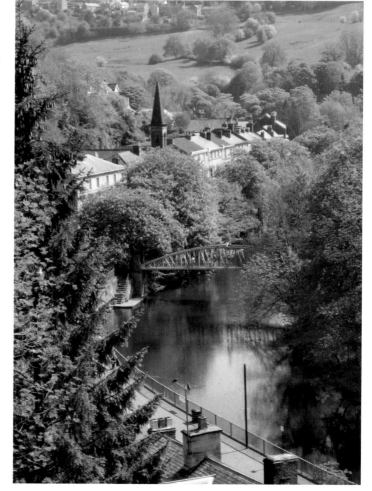

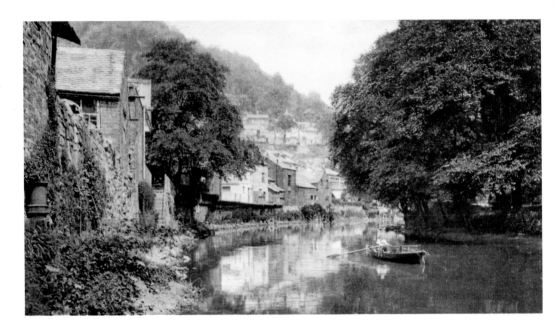

Enjoying the River

The Derwent has always played an important part in the life of Matlock Bath. The upper picture shows an excursion in a rowing boat while the lower picture shows the activity at the ferry point close to where the Grand Pavilion now stands. There were several ferry points for visitors to cross the river and enjoy walks on the far side of the river, from the Boathouse Inn down to this point. This ferry service still operates at certain times despite the construction of several footbridges over the years.

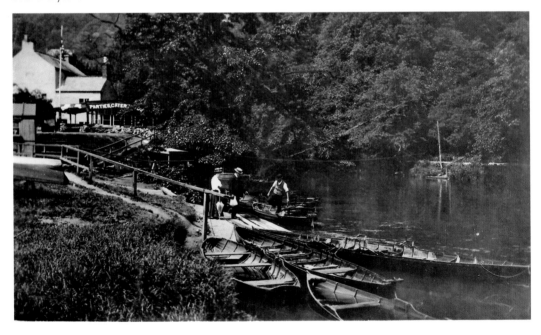

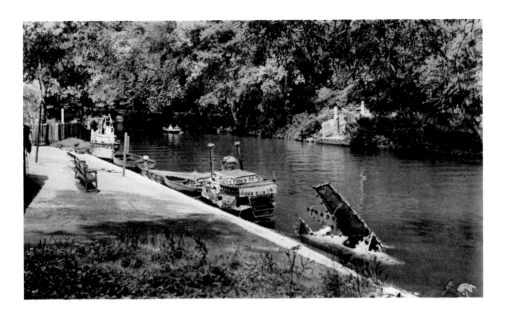

Enjoying the River

In most years since the Jubilee of 1897, Matlock Bath has seen a procession of illuminated boats along the Derwent. These illuminations still remain a popular feature with visitors usually taking place on weekend evenings in September and October. The upper picture shows boats being prepared for this event in the 1950s and the lower picture shows one of the decorated rafts taking part in the annual Boxing Day raft race in 1995.

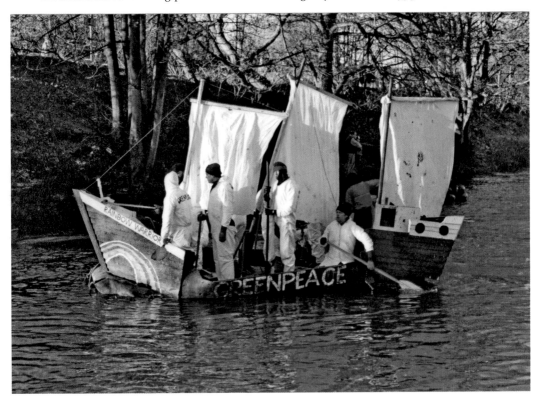

South Parade

Further along North Parade is one of the older buildings of Matlock Bath (upper photograph). Formerly known as Rose Cottage, with a date of *c.* 1612 above the door, this is now the Riva pub restaurant. At the end of North Parade (lower photograph) is Waterloo Road, leading to the higher levels of the town, and South Parade. Hodgkinson's Hotel, dating from the 1770s, is located at this junction.

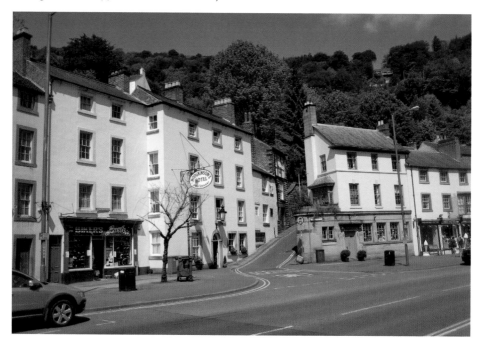

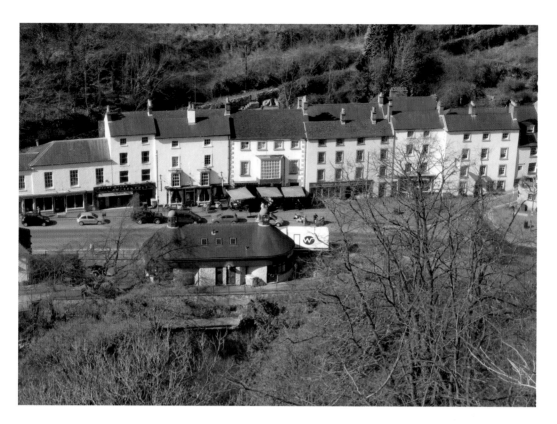

South Parade and the Fishpond

The upper photograph shows part of South Parade as viewed from the high level of Lovers' Walks, with the river in front of it and Hodgkinson's Hotel to the right. The lower photograph shows the next stretch of South Parade and the Fishpond. This pond has a collection of large decorative fish and a tufa centrepiece with a small fountain.

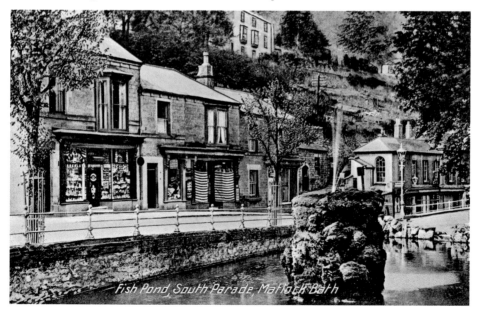

Fish Pond, South Parade, Matlock Bath

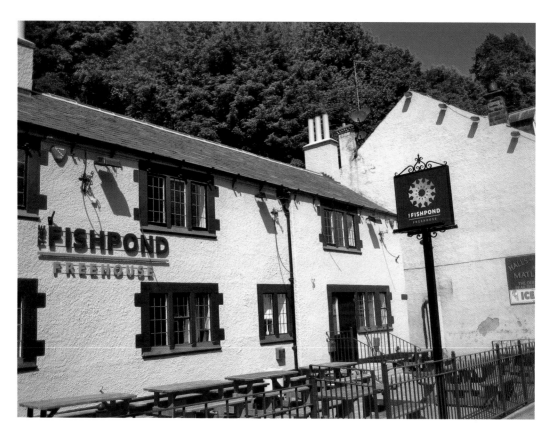

The Fishpond Hotel

This hotel is opposite the pond and the Grand Pavilion. It reopened in June 2012 after an extensive modernisation (upper photograph). The earlier stages of the site can be seen in the pictures on page 78; it seems likely that these earlier buildings were service buildings for the Old Bath Hotel.

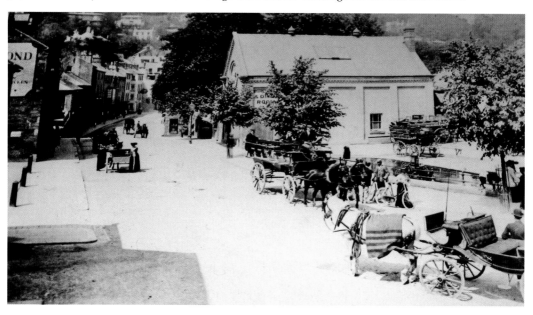

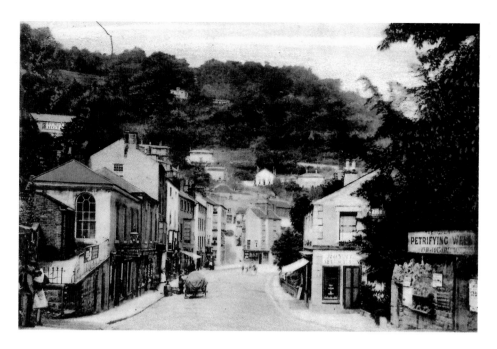

South Parade

The lower picture on page 70 shows the view along South Parade, looking north from the Fishpond Hotel. The large building on the right was Boden's Restaurant, now demolished. The photographs on this page are taken from a similar viewpoint, with a petrifying well shown on the right of the upper photograph and the terrace of the café at the Heights of Abraham visible on the skyline to the left of the lower photograph.

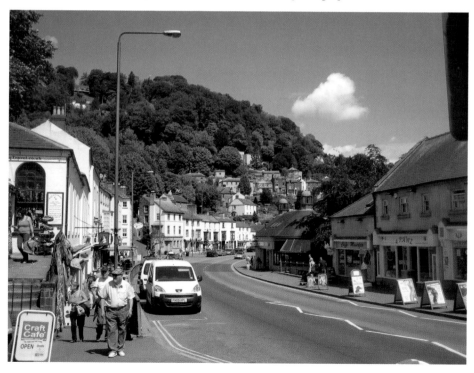

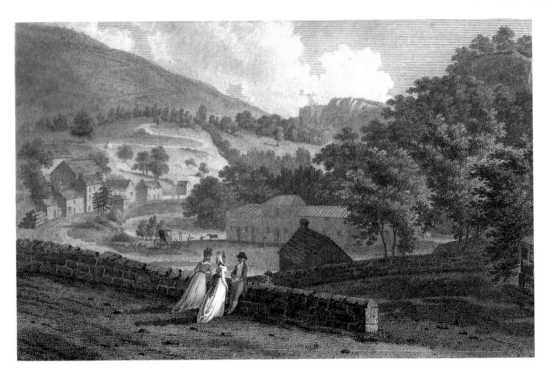

The Site of the Grand Pavilion

These two pictures were taken from what is now Temple Road looking down to the site where the Grand Pavilion would be built, and beyond. The large buildings to the right of the pictures are stables and service buildings for the hotels. In the upper picture (1794), there is relatively little development shown while in the lower picture (c. 1880) South Parade has developed and Prospect Tower is shown.

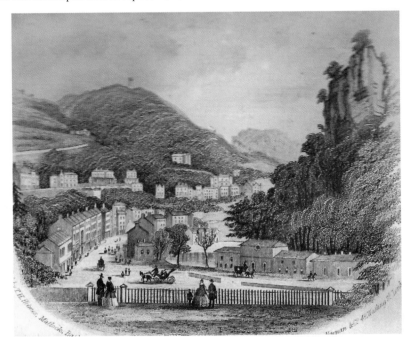

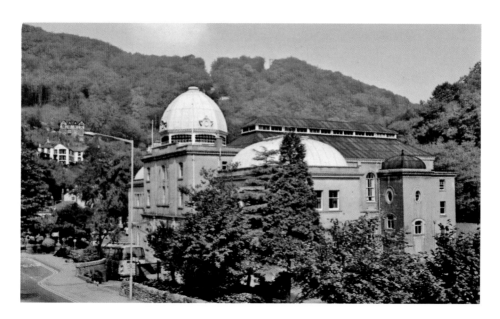

The Grand Pavilion

The Grand Pavilion, originally known as the Kursaal, was built in 1910, close to the site of the stable blocks shown on page 72. It provided a venue for a wide range of social and entertainment events and had a large function room with a stage on the first floor, a pump room where visitors could take the waters and other smaller rooms but, after various changes of use, including having a nightclub in the main room, much of the building fell into disuse.

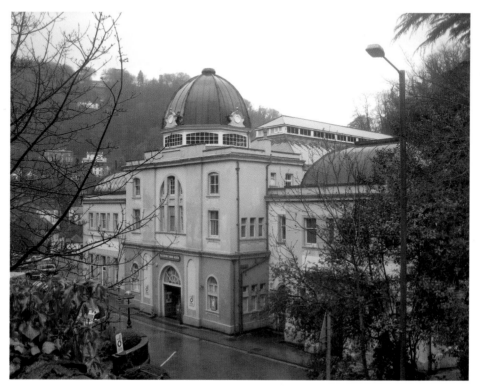

The Pavilion Interior

The upper picture shows the main room set up for a meeting in the 1980s. The Peak District Mining Museum (lower photograph) had been set up on the ground floor where it still continues in operation but a long term use was needed for the rest of the building. Local enthusiasts set up a company, Grand Pavilion Ltd, which, in May 2012, took out a lease on the building and started to implement a major restoration project.

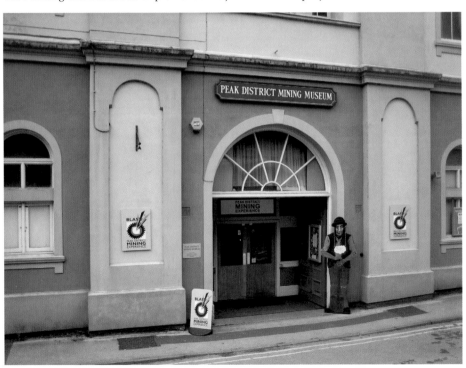

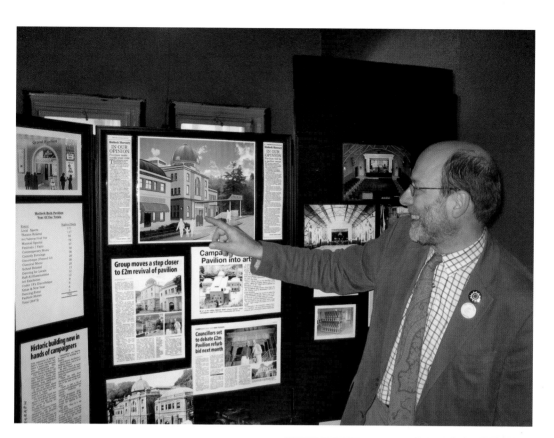

Looking to the Future

The launch event for the new enterprise was in the Diamond Jubilee weekend, June 2012, when a display of art, music and dance took place over three days. The upper picture shows Gregor McGregor, chairman of the company, explaining the imaginative plans for the restoration. With good local support, the company is currently engaged on a major fund raising campaign to take this project forward. The lower picture shows the original drinking fountain in the Pump Room, awaiting restoration.

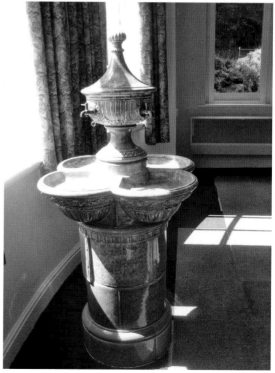

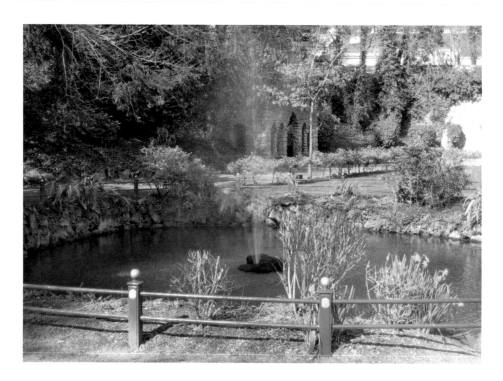

Lovers' Walks

Just behind the pavilion is one of the ferry points (for crossing to Lovers' Walks) and Derwent Gardens with its tufa grotto, fountains and ornamental pools. This is the fifth park in the continuous sequence along the eastern side of the Derwent, which starts at Hall Leys Park in Matlock. From here, a relatively new bridge (lower photograph) now leads to Lovers' Walks, which was set up as a public space in 1742 and is thought to be the oldest established park in the country.

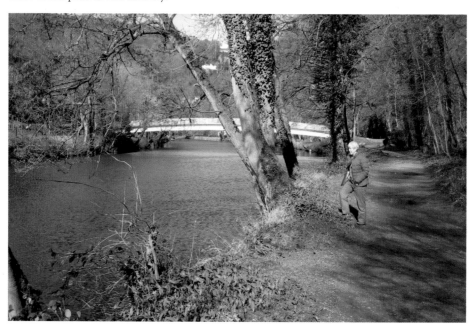

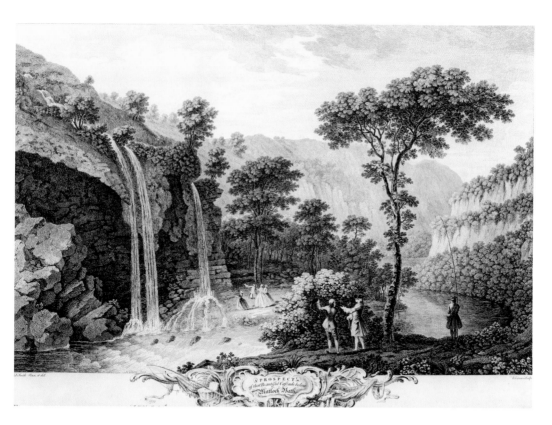

Lovers' Walks

The upper picture from 1743 shows the Cascades, a popular beauty spot as viewed across the river from Lovers' Walks. The lower picture shows Trinity Church from across the river and the 'Switchback', a former ride in what is now Derwent Gardens. The Walks extended along the east bank of the Derwent and then included a path at each end leading to the high ground above the dale, to give a circular walk with both riverside charm and extensive views from the high level.

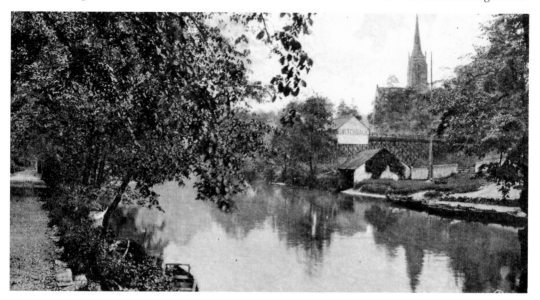

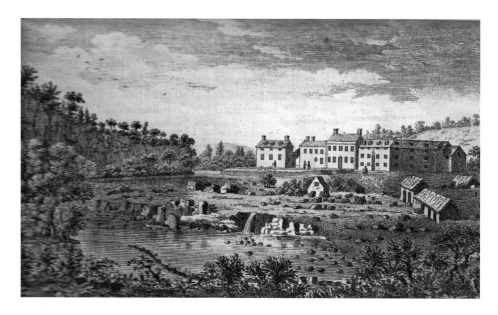

The Old Bath Hotel

The first treatment bath in the dale (Old Bath) was set up in 1698 and various associated buildings followed, leading to the development of the Old Bath Hotel. The upper picture (from across the river, 1780s) shows an early image of the Old Bath Hotel, high above the river with a rough track leading to it, with some buildings on the site of the present Fishpond Hotel. In the lower picture (1817), the track has been improved and more buildings have appeared at the lower level (including those seen from the other direction on page 72, lower picture).

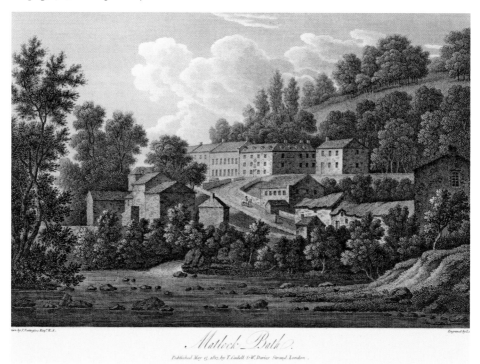

Matlock Bath.

Published May 15, 1817, by T. Cadell & W. Davies Strand, London.

78

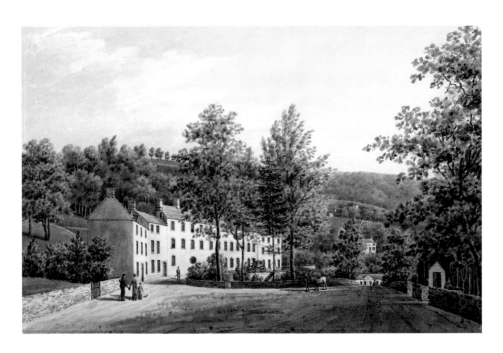

The Old Bath Hotel

The painting of the Old Bath Hotel in the upper picture was made by George Pickering in 1811 and shows the hotel at the peak of its popularity. The building was demolished in 1867 and the Royal Hotel (see page 84) was built on the same site. The lower photograph shows a spring and small pond with a tufa centrepiece between Temple Road and the former site of the Old Bath Hotel.

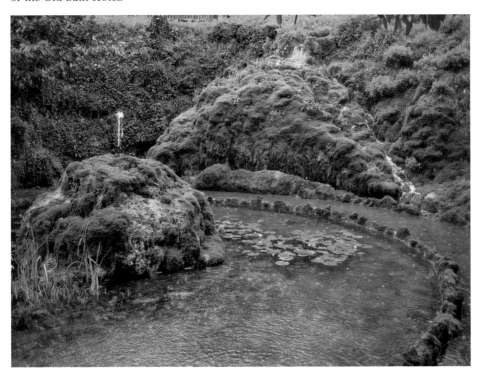

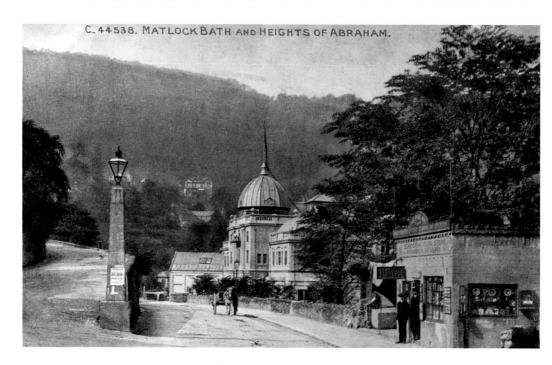

Temple Road

An important development in this area was the construction of Temple Road, shown to the left of the obelisk in the upper picture. Temple Road provided a less steep access to the Old Bath Hotel level than the track shown on page 78 and it helped to open up higher levels of the hillside to development. In the lower picture, the passengers on the donkeys are waiting on Temple Road to be taken up to the Heights of Abraham, avoiding a long steep climb on foot.

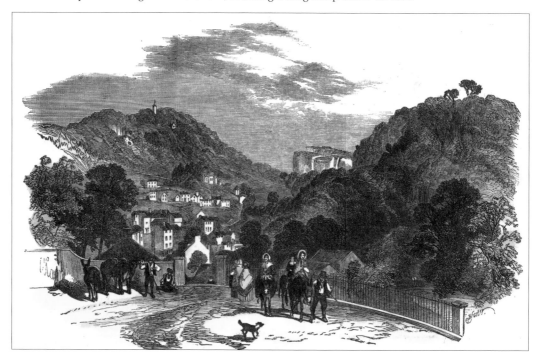

Temple Road

Along Temple Road, the upper photograph shows the entrance to Temple Mine, a former fluorspar mine which is now open for underground tours as part of the Peak District Mining Museum, a short distance away. The lower photograph shows the Temple Hotel, at one time an annex to the Old Bath Hotel but now an independent hotel with a splendid view across the dale.

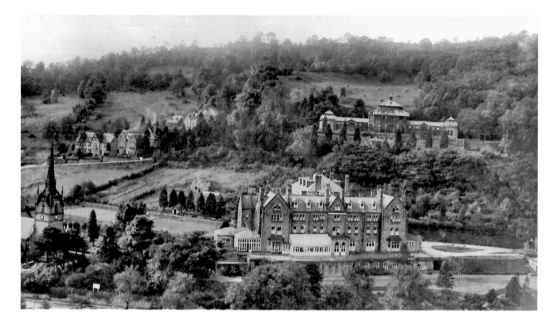

The Royal Hotel and the First Pavilion

After the demolition of the Old Bath Hotel, the Royal Hotel was built on part of that site; this hotel was destroyed by fire in 1927 and the site is now a car park. A glass and iron pavilion with surrounding pleasure grounds was built next to the Old Bath site. The upper picture shows the Royal Hotel with the Pavilion behind it, while the lower picture shows the Pavilion in more detail.

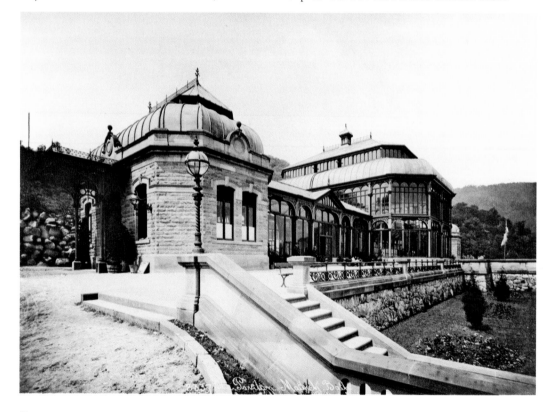

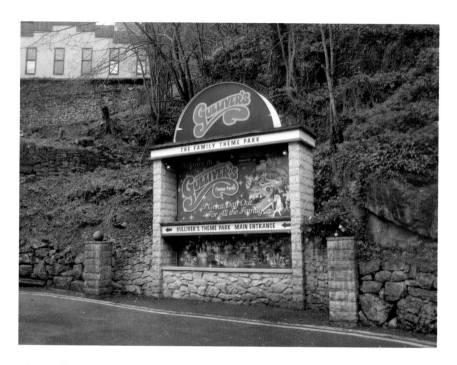

The Pavilion Site

The pleasure grounds closed and this Pavilion was demolished. The site stood empty for many years until the Gulliver's Kingdom theme park was opened there in the 1980s, which provides a wide range of rides and activities for young and old. In the lower photograph, taken from the top of Lovers' Walks, the Grand Pavilion, the Fishpond Hotel, the car park on the site of the Old Bath/Royal Hotel and Temple Road can be seen, with the rides and facilities of the theme park, set amongst extensive tree cover at a higher level.

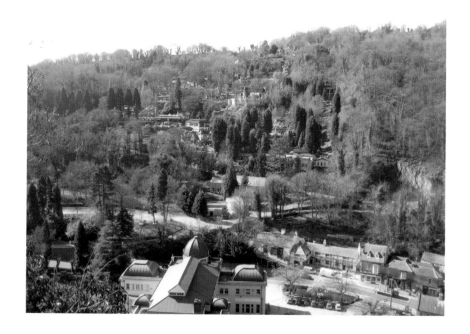

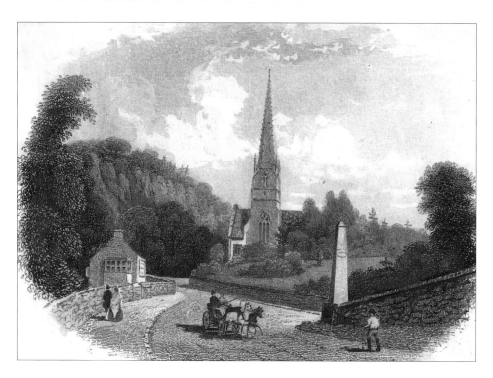

Trinity Church

Trinity Church was built in 1842 on a site to the south of the Old Bath Hotel and it was enlarged in 1873. In the upper picture, the obelisk marks the beginning of Temple Road, when looking south. The view in the lower picture is taken from across the river, with Trinity Church to the right and the New Bath Hotel to the left.

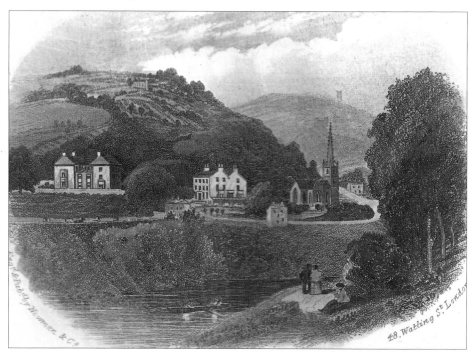

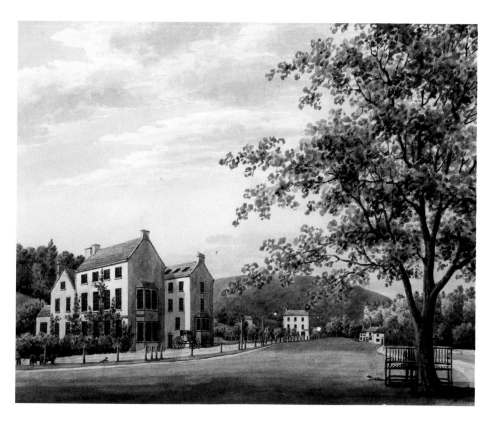

The New Bath Hotel

The 'New Bath' was established shortly after the 'Old Bath' at a second spring a short distance further south and the New Bath Hotel followed later. The upper picture of the New Bath Hotel is also by George Pickering, from 1811. The lower photograph shows the New Bath Hotel as it is today.

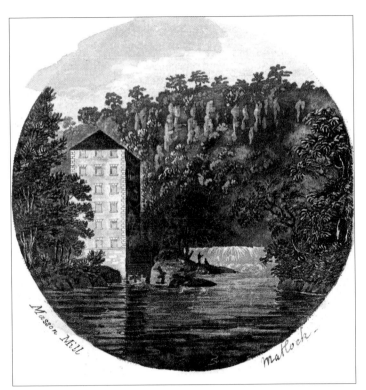

The World Heritage Site

The Derwent Valley World Heritage site starts at Masson Mill in Matlock Dale and extends to Derby, 15 miles away, along both sides of the Derwent. This designation was made in 2001 'to confirm the outstanding importance of the area as the birthplace of the factory system where in the eighteenth-century water power was successfully harnessed for textile production'. Arkwright's first mills were built at Cromford (see page 89) and Masson Mill (both pictures) was the first mill he built on the Derwent.

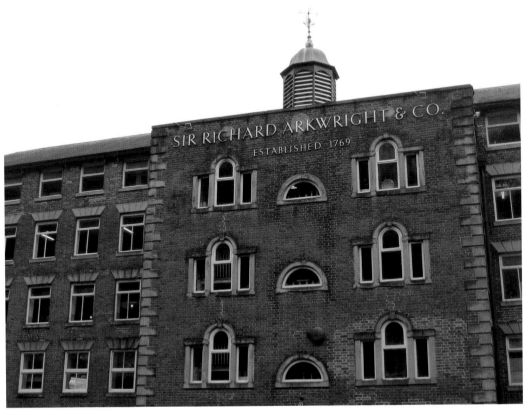

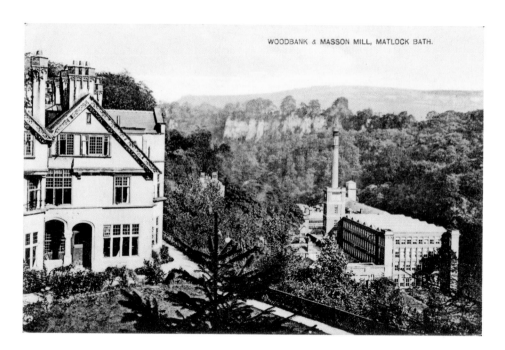

Masson Mill

This mill was built for cotton spinning by Sir Richard Arkwright in 1783 and there were many changes to the buildings over the years. The mill chimney dates from the 1900s. As steam-powered mills took over, its fortunes declined but it continued producing cotton until 1991. After a period of dereliction, it was extensively and sympathetically renovated and it reopened as the Masson Mill Shopping Village. There is also a museum on the site operated by the Arkwright Society.

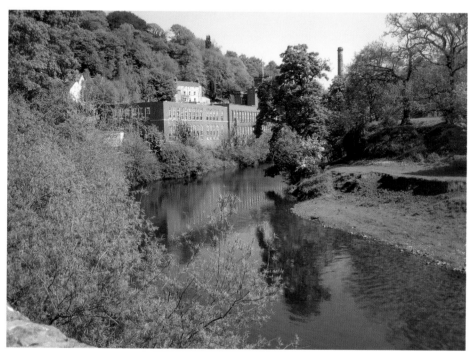

Scarthin Rocks & Willersley Castle

The upper picture shows the Derwent making a pronounced sweep to the left as it is deflected by Scarthin Rocks at Cromford. The gap inbetween the rocks, where the road runs, was created in 1815 to improve access to Matlock Dale. The large building to the left and in the lower photograph is Willersley Castle, which was built as a home for Sir Richard Arkwright, close to Masson Mill and the earlier Cromford Mills.

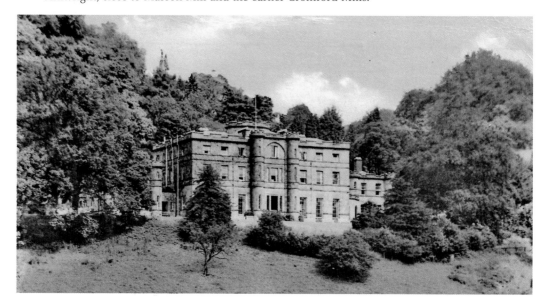

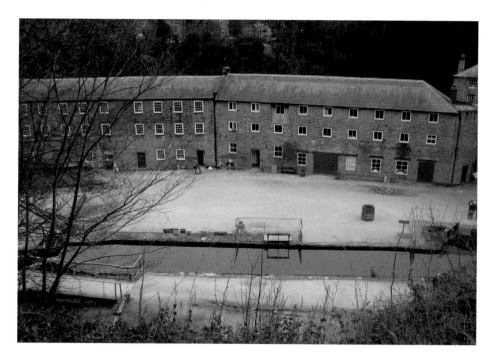

The Cromford Mills

Arkwright's earliest mills at Cromford are located on the far side of Scarthin Rocks and are not visible in the picture on page 88. The upper photograph on this page shows part of the mill complex, viewed from the top of Scarthin Rocks, while the lower photograph shows the mills as they are today, forming part of a large centre of historical interest for visitors.

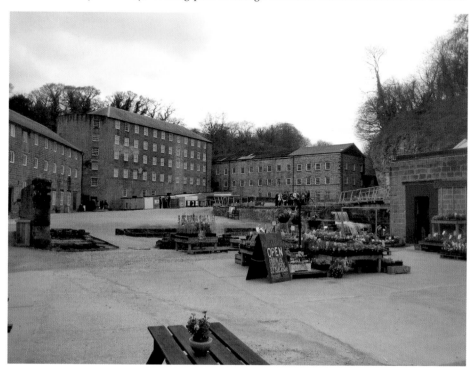

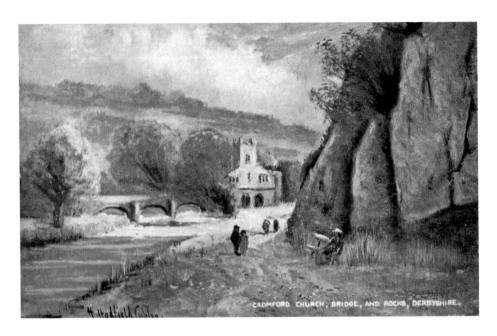

CROMFORD CHURCH, BRIDGE, AND ROCKS, DERBYSHIRE.

Cromford Bridge and Church

The upper picture (*c.* 1900) offers a final view of the Derwent as it passes Scarthin Rocks and on to Cromford Bridge, another ancient crossing point of the river. Cromford Church (also visible in upper picture page 88), next to the bridge, was built for Richard Arkwright but he died in 1792, before its completion in 1797. This route between Scarthin Rocks and the Derwent was the earliest of the modern routes into Matlock Dale from the south. In the lower photograph, a row of mature trees along the bank of the Derwent now obscures the view of the river but the church still remains on view.

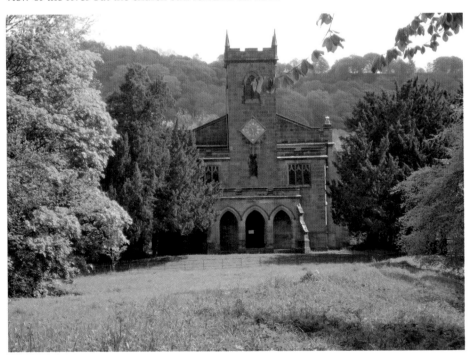

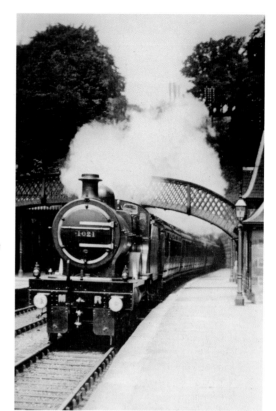

Cromford Station

Cromford station is located a short distance along the valley road from Cromford Bridge. In the upper photograph from 1900, the Manchester to London express is passing through the station. The lower photograph shows the former waiting room at the station, in a similar style to Matlock Bath station (page 58). This building is now a holiday apartment. The upper picture on page 88 also shows a locomotive with four carriages heading north towards Cromford station.

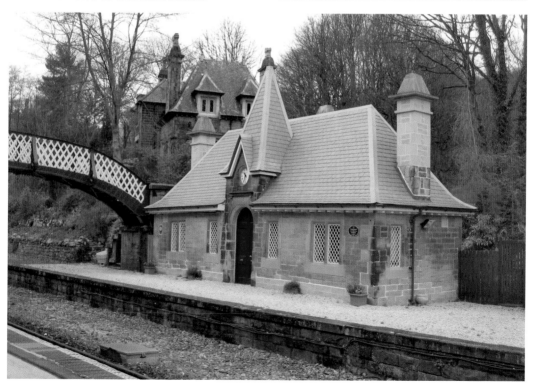

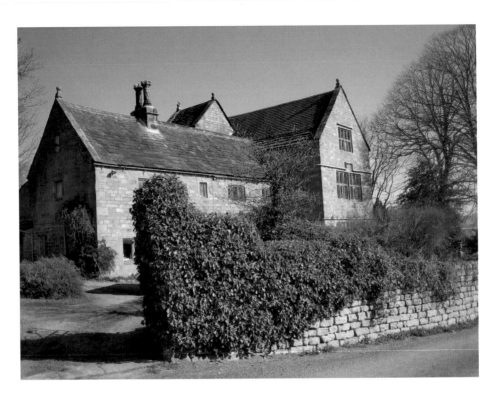

Riber Village

Travelling back towards Old Matlock from Cromford Bridge, along the old route from Wirksworth to Chesterfield, you reach Starkholmes and high above that village, along a narrow road with hairpin bends, is the tiny village of Riber, complete with its manor house (upper photograph), farm and church. In 1862, things changed when Joseph Smedley built Riber Castle (lower picture, 1912) for his house, the prominent building on the skyline that appears in several of the earlier pictures.

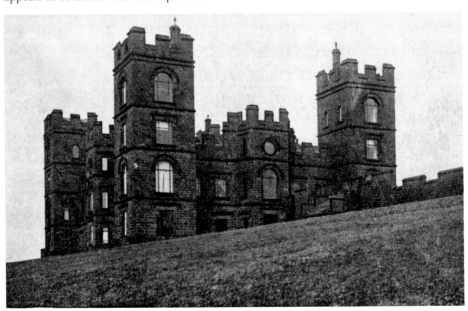

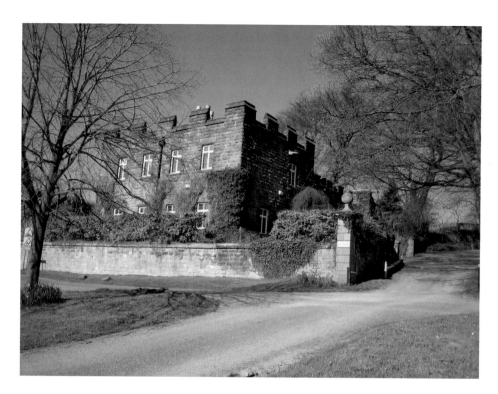

Riber Village

In more recent years, Riber Castle has been home to a wildlife park and a hotel. After a period of dereliction it is now being redeveloped as apartments. The upper photograph shows the lodge on the approach to Riber Castle, built in a similar style. The lower photograph gives a wide panoramic view which shows Riber Castle on the skyline, St Giles church to the left and Pic Tor in the middle, crowned by Matlock's War Memorial.

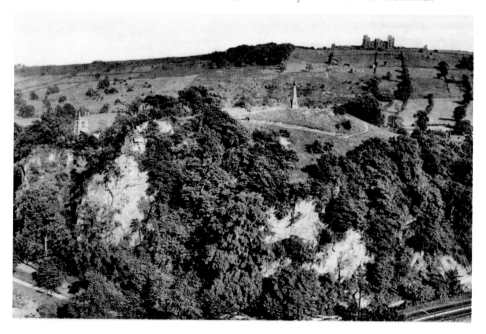

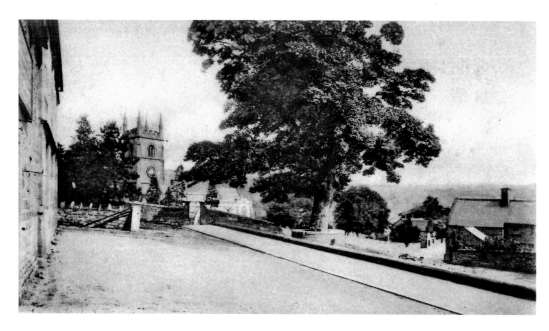

The Return to Old Matlock

Continuing northwards along the old road from Willersley and Starkholmes, completes the tour of Matlock and Matlock Bath, by returning to Old Matlock and St Giles Church. From the extensive churchyard, Matlock's War Memorial can be seen on the crest of Pic Tor.

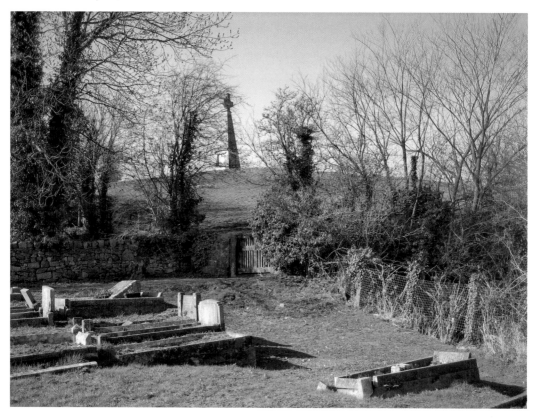

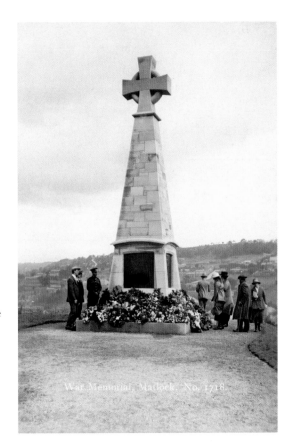

War Memorial, Matlock. No. 1718.

Memories

The War Memorial is an impressive
structure, beautifully situated
on Pic Tor, with extensive views
in all directions, to the Matlocks
and beyond. It is a peaceful and
thoughtful location to complete
the tour that started on the lower
slopes of Pic Tor and to recall the
memories of the journey.

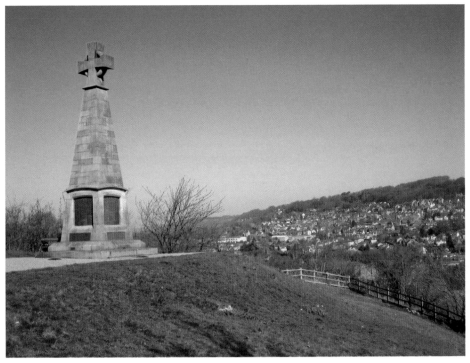

Acknowledgements

In these acknowledgements, images are identified by a two digit page number followed by 1 for the upper picture on the page and 2 for the lower picture on the page.

Picture the Past images may be located at www.picturethepast.org.uk.

These images are courtesy of Derbyshire Local Studies Library and Picture the Past:
05.1, 06.1, 08.1, 16.1, 17.1, 19.1, 20.1, 21.2, 24.1, 28.1, 30.1, 32.1, 33.1, 39.1, 41.2, 42.1, 47.1, 58.1, 69.2, 80.1, 82.2, 87.1, 92.2, 93.2, 95.1
These images are courtesy of Chesterfield Library volume of Churches and Views and Picture the Past:
77.1, 79.1, 85.1
These images are courtesy of Watford Museum and Picture the Past:
34.1, 38.1
These images are courtesy of Miss Frances Webb of Whaley Bridge and Picture the Past: 09.2, 10.1, 78.2, 86.1
These images are courtesy of Judy Jones and Picture the Past: 90.1, 91.1
Image 67.2: courtesy of Mrs Jane Arran and Picture the Past
Image 30.2: courtesy of *Derbyshire Times* and Picture the Past
Image 23.1: courtesy of Angus Watson (donor) and Picture the Past
Image 22.2: courtesy of Jean Margaret Caudwell and Picture the Past
Image 67.1: courtesy of the Johnson Collection and Picture the Past
Image 88.1: courtesy of DCC Environmental Services and Picture the Past
Image 55.1: courtesy of Mark Ludbrook
Images 74.1, 75.1, 75.2 courtesy of Gregor McGregor and Grand Pavilion Ltd

I would also like to acknowledge valuable comments and suggestions from Charles Beresford, Donna Hawkins, Peter Montgomery, Gregor McGregor and Kathy Roberts.